HAROLD
HITCHCOCK

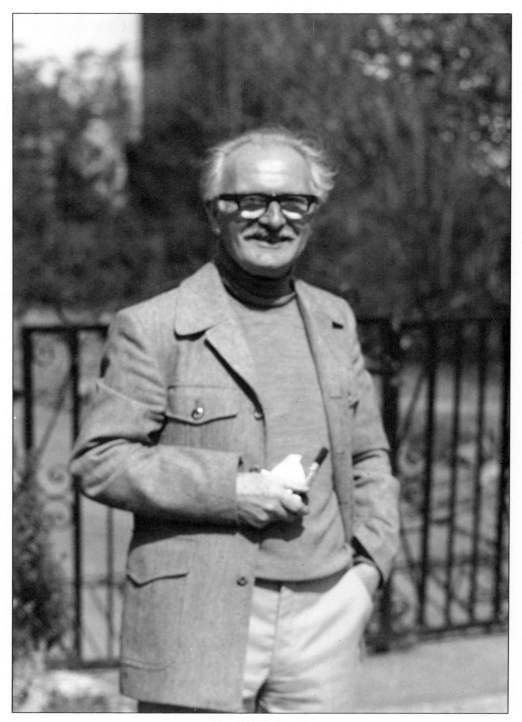

Harold Hitchcock

"I receive, as you can imagine, a good many photographs sent me by artists who hope that I will praise their work, and usually I am struck dumb, but in this case I am very much moved and impressed. It is rare to find an unashamedly romantic and literary artist. All criticism in the first half of this century was against them, so I not only admire Hitchcock's poetical imagination, but also his courage in persevering in his true style."

LORD CLARK

HAROLD HITCHCOCK

A Romantic Symbol in Surrealism

IAN WILLIAMSON

Foreword by Christopher Wright

Walker and Company • New York

ACKNOWLEDGMENTS

The photographs of Harold Hitchcock's paintings that appear in this work were taken by Dr. R. V. Schneider and James H. Allen.

The author is extremely grateful to Thomas Bayer for his support, his advice and his help in the creation of this book. He wishes to express his appreciation, as well, to the various individuals who own the paintings reproduced in these pages, all of whom prefer to remain anonymous.

I especially want to thank William and Kathryn Wohl for their efforts in furthering this book.

Library of Congress Cataloging in Publication Data

Williamson, Ian.
 Harold Hitchcock, a romantic symbol in surrealism.

 Includes index.
 1. Hitchcock, Harold. 2. Landscape painters—England—Biography. I. Title.
ND497.H54W54 1982 759.2 [B] 81-52549
ISBN 0-8027-0697-5 AACR2

First published in the United States of America in 1982 by the Walker Publishing Company, Inc.

Published simultaneously in Canada by John Wiley & Sons Canada, Limited, Rexdale, Ontario.

Designed by Joyce C. Weston

Printed in Hong Kong by South China Printing Company

10 9 8 7 6 5 4 3 2 1

MY SCIENTIFIC WORK IS MOTIVATED BY AN IRRESISTIBLE LONGING TO UNDERSTAND THE SECRETS OF NATURE AND BY NO OTHER FEELINGS. EVERYONE INVOLVED IN SCIENCE BECOMES CONVINCED THAT A SPIRIT IS MANIFEST IN THE LAWS OF THE UNIVERSE—A SPIRIT VASTLY SUPERIOR TO THAT OF MAN, AND ONE IN THE FACE OF WHICH WE WITH OUR MODEST POWERS MUST FEEL HUMBLE.

—ALBERT EINSTEIN

To Willie and Molly

Contents

Foreword

Most writers specializing in the Old Masters are wary of living artists. Their caution is due to the many mistakes made in the recent past. Almost all the writers on art living in the late nineteenth century attacked the Impressionists even when it had become obvious that their talents were changing the whole course of the history of painting. Translated into present-day terms, the criticism of living artists is usually left in the hands of specialists who have no interest in the art of the past. The reason for this curious position is that so much of the art of today has denied the existence of the past. The tastes of modern collectors, especially large corporations and museums, have been positively against any form of art that speaks of tradition.

A curiously large number of the people who are sensitive to many forms of art seem incapable of observing the difference between a *pasticheur* and a sincere artist who has chosen to adopt traditional methods. So many amateur art exhibitions, in reacting violently against the professional avant garde, hide their lack of confidence in careful imitations of Impressionist technique or style.

Hitchcock strikes the viewer by his uniqueness among present day artists. There are no parallels among the living for his landscapes of fantasy. For the historian a quite different problem is posed. Hitchcock, almost without realizing it, has taken up an enormous number of influences. In searching for parallel spirits in the art of the past there is the interesting case of Rembrandt himself, to whom Hitchcock never makes any reference. Rembrandt is always taken as the archetypal great Dutch artist, although he copied Persian miniatures and made a drawing after Leonardo da Vinci's fresco of *The Last Supper* in Milan after an engraving of it. Such disparate and unexpected references are never criticized by Rembrandt's admirers; they serve to underline his immense curiosity. By the same token Hitchcock unhesitatingly absorbs into his art a whole series of references, digesting them, and then transforming them into his own very personal vision.

The painter with the strongest influence on Hitchcock is Claude Lorrain, the seventeenth-century inventor of the idyllic landscape bathed in golden light. Hitchcock would probably deny this allusion on the grounds that he was not particularly familiar with Claude's work. Yet Hitchcock would admit an admiration for Turner, and a number of Turner's pictures were unashamedly derived from Claude, especially the

"Dido Building Carthage" in the National Gallery in London. Thus Hitchcock absorbs from more than one artist at once.

In trying to assimilate Turner's genius for the depiction of form dissolved by light, Hitchcock is so preoccupied with his own problems, especially with the forms of his giant trees, that the derivative nature of his exercise is totally forgotten. Hitchcock creates a primeval forest, a dream world whose literary source is much closer to Grimm's fairy tales than to the grandeur of Claude's classical landscape, or the light-saturated drama of a Turner.

Most of Hitchcock's pictures are in watercolor, occasionally heightened with body color, which turns them technically into gouache. In them, on this relatively modest scale, he has achieved his own form of art.

Every art historian, by the very nature of his job, tries to place his chosen artist or movement into the context of history. The references to Claude and to Turner, when pointed out, may heighten our appreciation but they do not seek to explain the painter's genius. My own reaction, on seeing Hitchcock's work for the first time, was one of surprise at his "Englishness." Several years ago, Nikolaus Pevsner wrote a brilliant but far too little-known book, *The Englishness of English Art*. As he was a German, he was able to perceive, through almost two thousand years of artistic provincialism, a whole series of threads running through our visual tradition.

The main characteristic of English art, as defined by Pevsner, is an unerring sense of decorative line. This comes out in antiquity in the linear decoration of a Celtic mirror back. A thousand years later it is seen in the quivering line of the Anglo-Saxon illustrator's pen in the *Benedictional of St. Aethelwold* in the British Library. It is further seen in the extreme complexity of late gothic vaulting. A similar preoccupation with linear effect is seen in the Elizabethan portrait miniatures of Nicholas Hilliard. In the early nineteenth century this tradition comes to a peak in the work of William Blake and is followed by the equally visionary but much less prolific Samuel Palmer.

Hitchcock slips almost unnoticed into this great tradition. His trees with their clumps of leaves and branches piled up on one another, like cumulus clouds in varying shades of deep green, have all the linear preoccupations of a medieval manuscript illuminator. The artist's own

deliberate sense of medievalism is limited to the figures, in the way they are dominated by and woven into the landscape pattern. To one's surprise, on close inspection the figures are seen to be clothed in twentieth-century dress. They are conscious idylls of our own time.

The only parallel in English twentieth-century art is the much-lamented Rex Whistler, killed at an early age during World War II, and a near contemporary of Hitchcock. Whistler's frescoes in the Tate Gallery restaurant and at Plas Newydd on the Isle of Anglesey concentrated on a light-hearted and good-humored decorative fantasy. Utterly derided in the 1950s and 1960s, they have now acquired a sense of nostalgia, even though the world they depict never existed. Hitchcock, less ambitious in scale than Whistler, is much more profound because of his brooding emotions. The sense of ominous foreboding is never far away. Yet the spectator is never depressed by Hitchcock's dark woods, because his art is too full of decorative exuberance.

Hitchcock works obsessively, pouring out his visions pell-mell onto the paper. As a consequence his pictures almost always work on an emotional level. The artist has no sense of formal composition as he covers the paper at will, as if he were an embroiderer working without a design. Such willfulness, when found in the art of the past, does not dull our appreciation of an Anglo-Saxon manucript, or our delight in a painter covering the walls of a medieval village church. The embroidered sensitivity of a Samuel Palmer watercolor does not make us hanker after a Michelangelo fresco; instead we accept that they exist on different levels.

In order to appreciate any painter on his own merits we have to forget as many of our prejudices as possible. We are all brainwashed in some way by the tidal wave of criticism in favor of very specific forms of living art. Artists who take extreme points of view when they hurl paint at a canvas and make a splash with it are exercizing their rightful freedom of expression. What we must ask ourselves is: What of the sensibilities and the taste of those who choose to admire such efforts? The critic must always respect the freedom of the artist; protest can only be effective by ignoring the meretricious and the pretentious.

None of us will live long enough to see who is right about the definition of art in our times. What is clear is that much which passes in the name of art will be consigned to oblivion precisely because it re-

quires so much explanation. Too many artists today think they can explain themselves with words when their problems are visual. As soon as they are dead they will no longer have their own built-in publicity neatly explaining what they really intended on the canvas.

As with every artist in the past, Hitchcock will have to stand on his own merits. Although I have never met him, I do not believe that the artist will have anything significant to say to me about his art. Everything he wants to say is in his pictures—and his chosen medium of expression is both moving and eloquent.

Christopher Wright
London, December, 1981

Preface

Ever since I was a child I have been fascinated with paintings and works of art even though I did not understand why. It was purely an intuitive thing. My grandfather was a collector and although I never knew the man, I did become acquainted with him through the paintings he had owned. I can recall vividly the enjoyment I experienced when viewing these mysterious objects on the wall. I would eagerly look forward to visiting my aunt's home where the paintings hung. Coffee and petit fours were served during these treasured afternoons, not the customary tea and biscuits of our native Scotland. The aroma of exotic coffee and the attractions of the canvases were heady stuff for a Scots lad. I was drawn back again and again to gaze and wonder.

In my teenage years I found myself wandering off to museums to scour their collections for my favorite pieces. Museums and libraries always gave me a sense of peace and security. Learning about previous generations and their attendant problems helped me understand myself better. The unconventional lives of artists, though frequently filled with hardship and tragedy, nonetheless seemed appealing. I did not know what the attraction was but perhaps it was the pursuit of their individuality. Although I could not imagine myself living the bohemian existence, the lives of Van Gogh and Modigliani personified the drama I felt within me.

In the course of time I started collecting paintings and with marriage to a Dutch woman became exposed to the great tradition of art in the Netherlands. I browsed through museums and read extensively to make sense of the bewildering number of styles and movements but could find no common denominator. Through an awareness of my own tastes I began to question existing values instead of taking them for granted. I repeatedly asked myself the question, "What allows a work of art to achieve a significant measure of recognition?" Slowly I became aware of deeper meanings and increasingly was attracted to art that gave me inner satisfaction. This I can identify as a need, a desire, or a curiosity to understand life in all its various aspects.

Then one day I was confronted by the paintings of Harold Hitchcock and was quite unprepared for their emotional impact on me; I had never before experienced similar feelings from an artist's work. The immediate attraction was the very beautiful nature of his creations. There was an indefinable quality, a spirit that was at once uplifting, mysterious, hyp-

notic, and tranquilizing. A rare beauty of atmospheric expression was achieved primarily through his rendition of the effects of light. A mood of peace and stillness permeated the works and stirred within me an awareness of something not yet understood. I felt that the beauty in his paintings was a mere external manifestation of some inner truth that eventually found form symbolically in light, as part of his philosophy on life that outer beauty was only the tip of the iceberg.

In time I met the artist briefly at an exhibition of his works and felt I had known the man for many years. Some months later it was my good fortune to converse alone with him for several hours in my home. We shared many mutual feelings. A rapport was established of such an order that Mr. Hitchcock volunteered that he had never before met anyone with such an intuitive grasp of his work. Despite my many attempts to dismiss this as flattery, I could not and was continually preoccupied with his presence. I was invited to England as his house guest on several occasions and was able to witness his remarkable technique of painting and learn his philosophy on life and the arts.

The true motivating force behind his work is the vision of life he holds. Life is a continuum and is timeless; we are all links in a chain. He believes in a Supreme Creator whose living, vital force is for all to witness as it is revealed in the miracle of nature. This life force is also manifested in man through his nature, the unconscious. It is felt as a drama within the artist, animating his existence and inspiring him to acts of artistic creation not entirely under his voluntary control. This spirit lives within his painting and communicates a mysterious uplifting quality to the viewer. An enchanting aura is perceived in contrast with the sterile world of technology engulfing twentieth-century man.

As a physician I have always been intrigued by the development of personality and character. The tribulations of this artist seemed to exemplify many facets of life from which the average person could draw inspiration. More specifically, in medical practice I noticed many occurrences that were not always what they appeared to be. Logic, although the controlling factor in modern life, does not necessarily provide the ephemeral happiness so often sought. The power of the human spirit has defied scientific medical knowledge countless times. Before and during my time in Vietnam as a medical officer, I saw extraordinary events under extreme circumstances, as one can in a war zone. The

inexplicable was repeatedly encountered in practice and led me to an awareness of other realities which were mysterious, healing, and of equal importance to the scientific. For example, foreknowledge, a sense of impending disaster, on the part of patients going to surgery is a sobering reality and should be heeded. Logically, we cannot accept such precognition by the unconscious, our alternate faculty. But in reality we know so little. Scientific theories of the day appear preposterous to subsequent generations.

I was immediately struck by a similar numinous presence in Hitchcock's paintings. But Hitchcock's paintings are models of hope and peace. I can identify a similar reality in patients sustained by some form of inner belief or faith. All of us are capable of experiencing such enrichment if we would pursue our own individuality as this artist has. Not only his paintings but also his life's struggle is inspirational, reaffirming my personal conviction that fulfillment will never flow from collective conformity.

Hitchcock's work is definitely "off-beat" in today's world and out of the mainstream of contemporary art. He is a solitary figure. The hallmark of modern art has been the banishment of all emotion as well as all living forms, a reaction against the stifling traditions of the past. This dehumanization produces art of no transcendent consequence and proceeds from the conviction that art must be precise, the high noon of the intellect. Since the work is pure and decontaminated of human considerations, one is free to enjoy only its aesthetic qualities.

In contrast, Hitchcock appears to be a Thoreau of the twentieth century, believing that man must follow his conscience regardless of the cost, that the world of woods and rivers is good while the world of cities and crowds is bad. His work is more than an escape into a fairytale world of dreams. The paintings are pleasant to contemplate and they also carry an important message to modern man—that we are a part of nature, have links with the past and must acquaint ourselves with our own unique humanity. Becoming thus spiritually aware, we will develop the same inner peace and joy that is present in his paintings, countering the emptiness and boredom of our materialistic society. In other words, he is pointing to a way out.

Hitchcock's message is not original; rather it is a restatement in new terms. Conceived in a technique called 'pictorial automatism' advocated

by André Breton in the Surrealistic Manifesto of 1924, it brings to Surrealism a most approachable subject matter. His technique of painting is disbelieved by most critics because intellectually it is incomprehensible. He is quite unaware of the content of much of his work because of the unconscious manner in which he produces it.

The whole thrust to Hitchcock's life has been his involvement with experiences and a world quite foreign to twentieth-century people. A visionary experience as a child at Thundersley, Essex (Plate 18), and meetings and eventual friendship with a mystic called the "Boy" subsequently led to the flowering of the painter's spiritual message. The Boy was a channel of communication for spiritual beings, the Brothers, who gave advice and aid to persons in trouble. Hitchcock in his turn has become a vehicle for the transmission of certain aspects of these teachings. He is a mystic in his own right providing spiritual illumination for others. His paintings are associated with many bizarre stories (like the one beginning on page 67) and exert a profound influence on many people's lives.

From my personal conversations and friendship with Mr. Hitchcock and through study of his paintings, I will endeavor to explain the correlation of the formative experiences in the artist's life and his development as a visionary painter. Of particular importance are his childhood experiences and the concept of the collective unconscious as postulated by Dr. Carl Jung.

COLOR PLATES

Introduction

L ife is petty and inconsequential unless moved by a desire to expand its boundaries; to live continuously within narrow confines betrays a decline of vital energies. The urge to break out is characterized in the visual arts by frequent stylistic variations.

Until the twentieth century, the subject matter of art dealt with this breaking out, addressing itself to the most profound problems of humanity. As a consequence, art was considered an activity of great importance. But twentieth-century art—the new style of art deemed "modern" has as its salient feature a tendency to renounce its own importance. It is seen by the younger generation as a thing of little consequence, executed with tongue in cheek and laced with irony. Its farcical nature is the primary reason why serious minded people find it incomprehensible. However, the jesting nature of the new style may be its principal virtue, an attempt to instill youth into an old or extremely weighty pursuit.

New styles have historically burgeoned as a reaction against the stifling traditions of the past and customarily survive an initial period of quarantine. Modern art, however, retains an unpopularity with the masses which is undiminished with the passage of time. It has acted like a social agent segregating the public into a hostile majority and an elite minority. Its unpopularity with the masses stems from their lack of understanding of it, which gives rise to feelings of inferiority and indignation on their part.

The modern artist maintains that emotions are aesthetic frauds and that grieving and rejoicing at human destinies in a painting obstructs the aesthetic appreciation of the work. Thus there has been a progressive elimination of the human elements predominant in previous movements. This purification and iconoclastic urge gave birth to a form of expression that can only be appreciated by those people possessing the faculty of aesthetic sensibility. This ability to enjoy the formal elements alone, in splendid isolation, is shared by a new order of people who are not better but simply different. The viewer must observe and not live reality. Since art has been dehumanized and purged of all emotion, it is of no transcendent importance, and it is precisely this which interests the modern artist. It is the antithesis of Greek art which, at its height, was so deeply in love with the human form.

Fundamental changes in man's attitude to life frequently surface in the field of artistic endeavor. With the aforementioned stylistic mutation

in mind, the question arises whether this is a harbinger of some new or existing way of life. The sometimes monotonous and sterile modern art forms seemingly mirror the empty and boring lives experienced by so many twentieth-century people. Ortega y Gasset posed this question in regard to the modern artist: "Is it conceivable that modern western man bears a rankling grudge against his own historical essence? Does he feel something akin to the *odium professionis* of medieval monks—that aversion, after long years of monastic discipline, against the very rules that had shaped their lives?"

This modern foray into extreme abstraction has unquestioned validity as a cleanser at this particular juncture in art—a sort of monument to man's intellect, whatever that may be worth. As a form of expression, however, it would appear to be limited and confining, a shallow mine that may be worked out rather quickly. This shortcoming, among others, led this author to seek another type of art which is not dehumanized but which does not follow beaten and worn-out paths.

Such a form of expression is to be found in the work of Harold Hitchcock, whose art, unlike that of most of his contemporaries, does relate to life. He projects the spirit of nature in a unique manner by means of his feelings. His paintings are waking dreams, magical concoctions which have no counterpart in previous art, and they are supportive of the mystical notions of Carl Jung, who believed that much of our behavior is governed by ancient memories that are passed from generation to generation and that steer our feelings from some back room of the brain.

As such, Hitchcock's paintings are bread to a world which hungers for truth and for a renaissance of the human values it lost since being catapulted into the computer age. His paintings are of transcendent consequence and enrich the world by adding to it the contents of his imagination. He speaks with authority of nature's moods, and his towering trees seem to reach down to the very root of life itself (Plate 29).

We in today's world are swept along by the necessity to conform, to be efficient, and to be productive in a mechanized society. Hitchcock, the man and the artist, states that an alternate path exists involving the development of an inner world to balance the outer. It is the same message found in the French fable by Saint-Exupéry in which the fox tells the Little Prince the secret of what is really important in life—namely that it is only with the heart that one can see rightly; that what is essen-

tial is invisible to the eye. As the rhizome provides hidden growth for the plant, so Hitchcock's gnarled tree roots powerfully symbolize life's inner sustenance.

The aesthetics, craftsmanship, and unique forms of his paintings alone would suffice to answer the question posed concerning the importance of Hitchcock's art in the twentieth century. Beyond these considerations are others of equal import, involving the very survival of man himself.

Hitchcock has noticed, as many others have, that simple people have a greater sense of the wholeness of life than their more educated counterparts. They are wiser and more in touch with the realities of human existence. Like Tolstoy he feels that art should be like a parable expounding life's goodness and truth and beauty in terms comprehensible to everyone, not just to a specialized elite. Both have shared a special relationship with life—the trees, the sun, the toil and passions of men—whereby an understanding of its true nature emerges. As a poet pursuing the truth through his unique relationship with nature Hitchcock understands that:

> *Sweet is the lore which nature brings;*
> *Our meddling intellect*
> *Mis-shapes the beauteous forms of things:—*
> *We murder to dissect.*
>
> —*WORDSWORTH*

The fire within this artist has burned away everything extraneous that could have diverted him from his search for the true meaning of life. He sought this truth by emotional, not intellectual, means, sensing that the powerful forces that provide inspiration are within us and cannot be imposed from without, however ingenious the artistic theory of the day. In reality we are obliged to live to some extent in the realm of myth if only to preserve a certain innocence that makes it possible to invest emotional energy in our relationships and activities. Explanatory myth rather than demonstrable fact has been, and still is, the basis of much we believe in. Hitchcock's work is not only a philosophical reflection on the enigma of being but an example of a painter's attempt to translate his ideas and emotions into their visual equivalents as a synthesis of color and form.

Paradoxically, although Hitchcock followed his inner promptings scrupulously and never was pushed into any school or fashion, he nonetheless finds himself in the position of fulfilling the automatous visual reality as theorized by André Breton in 1924.

Surrealism in the visual arts strives to reveal the imagery of the unconscious and to unlock its meaning. It is only one of many searchlights used by man to penetrate the darkness of his inner mind. It is singularly more successful than its literary beginnings in achieving this end because culturally the word is younger and lacks the powerful *numen* possessed by the archetypal images that flower from the unconscious.

In philosophical terms Surrealism is a broad attempt to define and investigate the meaning of life by rejecting the primacy of logic alone. In this regard it was fueled by the German philosophers from Kant to Nietzsche and by the psychoanalytical theories of Sigmund Freud and Carl Jung.

Structuralism is a method of analysis used to express the cryptic meaning of a creation, whether literary, linguistic, or artistic. Freud pioneered the discovery of structures beneath the surface of the human personality. His work was interpreted by Dali who consciously attempted to inject sexual and other symbols into his work. Thus Dali and other illusionist surrealists like Magritte and Delvaux use Freudian theories to explore the irrational world of the unconscious.

Following the psychoanalytical theories of Sigmund Freud came those of Carl Gustav Jung. A friend and initially a pupil of Freud, he broke from him early in his career. He could not accept Freud's passion for explaining away complex psychic phenomena like art, philosophy, and religion as repression of sexual instinct. This negative or reductive theory towards accepted cultural values Jung correctly saw as a reaction by Freud against the repressive and sham Victorian values that surrounded him. A general psychological theory claiming to be scientific cannot be based on the malformation of nineteenth-century Europe, but must be broad enough to comprehend all humanity. Jung penetrated into that deeper layer of the psyche common to all men, amplified the concept of the dream being the "Via Regia" to the unconscious and reinvested it with the lofty significance and dignity of an oracle. Hitchcock's paintings are the visual embodiment of Jung's philosophy.

The terms "introvert," "extrovert," and "archetype" are all Jungian concepts, but his outstanding contribution to psychological understanding was his vision of the "collective unconscious." He saw the unconscious in terms of an adviser and friend and not as a glory-hole of repressed desires. Its language, he stated, was symbols and archetypes, and the vehicle of communication was dreams, which are normal psychic emanations guiding the individual. The content of many dreams is of such a nature that it cannot be explained in terms of the individual's personal experiences alone. The striking similarity to ancient myths led Jung to believe there was a collective basis to dreams. In the medieval alchemists' experiments he found the missing link between the modern age and antiquity. Although their struggle was intended to unlock the secrets of chemical transformation, it was at the same time the reflection of a parallel natural psychic process. The symbolism of alchemy, and also of Hitchcock's art to some extent, expresses the evolution of personality, the individuation process as identified by Jung.

This self-governing process resides in our ancient psyche and is innate. It is the directing principle that brings order to our conscious attitudes and personalities, if you will. Just as an aggregate of people without some central authority degenerates into a mob, so the human mind becomes dissociated or chaotic if it lacks organization of its component parts.

The reconciliation of the contradictions and mystery in life, their synthesis into a philosophy, is achieved by the instructive symbolic visual images of the unconscious. Before this goal of synthesis is achieved, these images must be made known to the individual and this cannot occur without their being experienced as an inner reality. Experience leads to understanding and generates loyalty or trust in this inner guidance, which may become so commanding as to take possession of the person.

In medieval times, as part of their general philosophy of life, the alchemists projected these symbolic visual images into the phenomena of chemical change, as Goethe did in his writings and which Hitchcock now does in his pictures. Their forms may be infinite in variation, but are all variants of central types occurring universally. The process that produces them is the journey people must travel to realize their uniqueness and thus become psychologically congruent in the second half of

life. It is a process as boundless as nature. It endows the person with mental resiliency in life and makes Hitchcock the man and artist he is to this day.

Ultimately the unfettered expression of human nature adds to our comprehension of life. By allowing himself to live in his own personal myth, the most courageous path of all to follow, this artist has produced a laboratory of dream images which are a visual proof of Jung's theories of the collective unconscious, of myth, and of man's inherent spiritual nature.

As he was swept along Hitchcock struggled to harmonize the historical family inside him with the insanity he encountered in the outside world. Although he lived in a constant state of tension produced by the assaults from the unconscious, he endured because of an unswerving conviction that he was obeying some higher will. His paintings produced themselves; they have a life of their own and are the outcome of the transformation within him that Goethe similarly had experienced in producing Faust, both artists sacrificing the everyday activities of life to the overwhelming creative passion to express the longings of their times. That which was alive and well in Goethe as a living reality is the same great dream that haunts Hitchcock. His life is now enacted within the framework of this drama.

The point of Hitchcock's art is that it represents his confrontation with the unconscious and exemplifies the positive aspects of such a confrontation in elevating his concept of life above the mundane. His paintings are not disguised images censored by the mind or crafty devices to lead us astray but are statements of incomparable beauty from human nature itself, directly communicated independent of any analysis.

Part I

THE MAN

Formative Experiences

It is said that the seed of artistic genius has a germinating power sufficient to crack any stone and that men become artists because of the inevitability of their calling. The facts of Hitchcock's life seem to bear this out.

Born Raymond Hitchcock on May 23, 1914, in a small nursing home in Kentish Town, London, the eldest of three siblings, he was later to change his name to Harold on entry into the Subud Brotherhood. At the moment of his birth an incident occurred presaging in remarkable fashion the rest of his life. Inexplicable in modern scientific terms, nonetheless it can be attested to by many family members who at the time were living in a house reputed to be haunted. A long-silent grandfather clock began to strike for the first and only time in years and was accompanied by tumultuous noises—so much so that a lodger and his dog dispatched to investigate, returned cringing in terror.

During Hitchcock's infancy his father owned a flourishing hotel in the city. The family lived in relative affluence, having a nurse and similar comforts, enjoying what must have seemed to them a period of luxury. The impracticality of the elder Hitchcock quickly ran the family business into bankruptcy shortly after the end of the First World War, and so off the children went to their maternal grandparents at Thundersley, Essex, for shelter. For a brief spell thereafter the family was reunited on a farm purchased by Hitchcock's father as a business venture, but once again bankruptcy occurred and the children returned to Thundersley.

In this quiet, sleepy little village after the Great War, Harold Hitchcock had experiences that were the basis of happy childhood memories and were to prove the strength and spiritual inspiration for his future career as an artist. His maternal grandparents greatly influenced his development. His grandfather, a retired schoolmaster with a commanding manner, imbued the children with feelings of love and gentility. In his forty-odd years as a teacher, his proudest achievement was that he never used corporal punishment. This grandparent was a great stabilizing influence on this sensitive young boy. His intuitive understanding of the struggle within the young Hitchcock prompted him to encourage the artist to paint. In fact, he was the person who gave Hitchcock his first painting lessons. He was beloved by all the children, and Hitchcock reflected this sensitive communication by painting his grandfather (his first portrait) at the age of nine. He then progressed towards painting the

The clock of Frederick the Great, which stopped in 1786 when its owner died. Camera Press Ltd., London.

(far right) Hitchcock's paternal grandfather with the shield he created to commemorate the Sydney Street Siege.

surrounding scenery, and his first landscape included the figure of his sister Madelaine picking blackberries on the hill overlooking grandfather's garden. However, his passion for the artistic had revealed itself at a much earlier age. He was always well remembered for having preferred to be alone with pencil or brush, rather than to play with the other children in the village as his brother and sister did. From the age of six, he incessantly told stories of a highly imaginative nature and wrote verse. These stories were of such charm that an uncle encouraged him to talk for hours, jotted them down, and attempted (unsuccessfully) to have them published and broadcast on BBC radio.

The other children in the family were in awe of Harold because he appeared to be more clever than they. For them his adult work always recreates the country pleasures of their youth, evoking memories of halcyon days with their grandparents.

It was during one of these childhood stays in Essex that Hitchcock experienced the single most formative event of his life. (Plate 18) He recalls it many years later as a mature man:

At the end of this huge garden that my grandfather had, there were a number of giant elm trees. To a small child they were particularly majestic in the summer with their foliage in full bloom. I used to wake up in the early morning and wander down to the foot of the garden. The giant elm trees faced east. The sun used to rise up at the back of the trees, and with their tremendous expanse of foliage the rays of the sun would splay out in a huge arc. One particular morning I was watching this when I suddenly

felt beside myself with joy. It was a very ecstatic feeling, and so intense, that I have to this day never really recaptured the feeling, though the influence remains very strong. It was that one moment that touched off something within me, and made me wish to recapture it through painting. There was a wonderful feeling of harmony and well-being and peace. In particular the sunlight on the bark and roots of the trees presented a scintillating, jewel-like vision of colour. I remember saying to myself that I would not rest until I had somehow recaptured something of this vision or experience however vaguely.

When Hitchcock told me the story of Thundersley it was a deeply moving experience to see this dignified man in the grip of an overwhelming emotion. He had realized intuitively that he was part of a great natural order, the "majestic clockwork," and that all living things existed for a divine purpose. He was part of a greater whole and the feeling of grace which accompanied this insight gave voice to exalted emotions and transcendence. Each of us has felt a sense of elation when exposed to some glorious aspect of nature. We differ from the artist only in the intensity of response. By recapturing the spirit of that occasion he has been able, all his life, to project mystical overtones into his work, primarily by his handling of light. This spiritual illumination was self-evident to an Indian mystic some years later and provides an explanation for his prediction that Hitchcock "would be a light unto others."

And so Harold Hitchcock began to draw and paint under the tutelage and watchful eye of his grandfather who kindled within the young artist love and respect for the natural environment. Hitchcock avows repeatedly that he owes more to that man for his great kindness and encouragement than to anyone else.

Hitchcock came from a family of diverse artistic talent. His paternal grandfather from Somerset was a woodcarver and some of his work can be seen on the main chancel of Exeter Cathedral and also in the Exeter Guild Hall. During the Churchill years he was commissioned to fashion a shield commemorating the Sydney Street Siege, which hangs in the East End of London to this day. Through his maternal grandparents he is related to George Stubbs, the eminent English animal painter whose precision in anatomic detail is legendary. Hitchcock well remembers and regrets his inattentiveness to the stories his grandmother related about this illustrious ancestor.

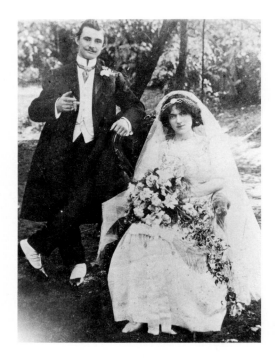

Hitchcock's parents on their wedding day.

His mother came from a talented musical family, she herself being a pianist who played in the London cinemas and theatres by necessity. As the family breadwinner following the departure of her husband to sea, and because of her repeated absence from home, there was no alternative but to dispatch the children to Thundersley.

Two of Hitchcock's uncles were professional musicians (one played for the Royal Philharmonic Orchestra, the other for the London Symphony Orchestra) and both men, in addition, were artists in their own right exhibiting regularly at the Royal Academy. Another relative was an opera singer, and at family gatherings the children would sit enthralled, listening to the glorious music being played and sung. So the children were raised in a cosmopolitan atmosphere, and although touched by adversity, they were exposed to a cultural environment which bred and fostered an appreciation of music and the arts.

When the time came for the family to return to London, the young artist vividly recalls being unable to face the prospect of living in the city. He dug in his heels and refused to go. But the return was made and the family relocated in a studio apartment with a large skylight in St. Johns Wood, London. He found it a very satisfying place to paint and he regards this period in the studio apartment as a happy time of his life.

At the age of thirteen Hitchcock produced a painting on a huge ornamental mirror measuring five feet by six feet. He required a long ladder to reach the top of it and worked from the top down. As is his custom, the subject of his paintings was always the same: imaginary natural landscapes. This particular large work was seen by Dame Laura

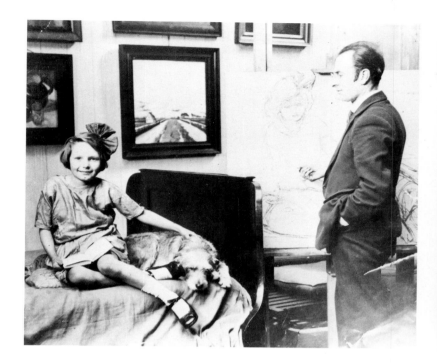

Knight, who expressed a high regard for it. Shortly thereafter he received a substantial write-up in a British newspaper and was proclaimed a child prodigy of the day.

One Sunday, at the age of fifteen, Hitchcock visited the National Gallery with his father and instinctively gravitated towards the paintings of Claude Lorrain. The only conclusion he can draw from this is that he and Claude were kindred spirits. (Plates 6, 11 and 27) Claude, in particular, achieved a quality of light and projected an atmosphere of peace in his oeuvre which appealed greatly to Hitchcock. In all probability he was unconsciously reminded of similar qualities that he had sensed in that magical moment in his grandfather's garden at Thundersley (Plate 18).

Though he never copied Claude, always preferring to follow his own inner promptings, light unwittingly became a major element of many of his works, the very same light he saw sparkling and dancing with jewel-like effect off the elm trees. Hitchcock's rationale for reproducing the effect of light he postulates as follows: "Light is only at its strongest in any painting when the details that reflect the light are perfectly articulated. It is noteworthy that Claude, the first artist to paint light, was a superb draughtsman. It was a combination of technical supremacy and inspiration that made his light scintillating and crystalline, because every detail was painted with loving care."

The longer he lived in the city the more increasingly unhappy the young artist became. Life's harsh realities made his early adulthood a grim struggle to keep in balance his extremely sensitive nature. Exposed to many trying experiences, as we all are, he felt them more poignantly

(above left) Hitchcock's sister Madeleine with their uncle Cyril, an accomplished musician and painter who exhibited at the Royal Academy.

(above right) The portrait of Hitchcock's grandfather, painted when the artist was nine years old.

than most, and suffered silently. He became nervous and partly neurotic; he was doing commercial art work, which was wasteful of his vision and consequently soul-destroying. The only way he could keep heart was to paint in his spare time, but he was unable to finish any work to his satisfaction.

Hitchcock's paintings at this time tended to be dark and gloomy, mirroring his inner spiritual crisis. He was a man on a journey but ignorant of his destination. However, certain events that occurred in his life then and influenced the outcome of his career, Hitchcock now believes occurred not simply by chance. He feels he was destined to meet unusual people at certain points in time and be told to achieve definite objectives.

Hitchcock recalls one afternoon in 1934 when he and a young school friend sauntered into a Camden Town pub. His friend was an extrovert who played the guitar and who was, in fact, the antithesis of the artist. As they were standing at the bar having a drink and talking, a complete stranger pushed himself between the two young men, transfixed Hitchcock with his gaze, and asked if he could buy him a drink. A conversation ensued in the course of which the gentleman asked Hitchcock a multitude of questions about himself. Bewildered by this, Hitchcock asked if they had met before. Although the reply was a negative one, the man expressed strong feelings of recognition. He told the young artist that although he was experiencing difficulties, he was not to worry; that in spite of many obstacles things would work out for the better; that he should continue to do the best he could, for eventually there would be a successful outcome. The stranger then changed the subject completely, finished his drink, said goodbye, and departed, never to be seen again. These encouraging words when his spirits were at a low ebb stimulated Hitchcock to go on. The artist only remembers this chance acquaintance wearing a cloth cap and an old pair of baggy pants, but he admits that he believes this to be the same person as the "Boy." The incident had such a bearing on Hitchcock that he changed jobs, and his life took on a new direction.

The years that followed prior to the outbreak of the Second World War were not particularly times of great growth for him. He does recall looking at the trees in the countryside one day at the age of twenty-five and bursting spontaneously into tears because of the realization that he

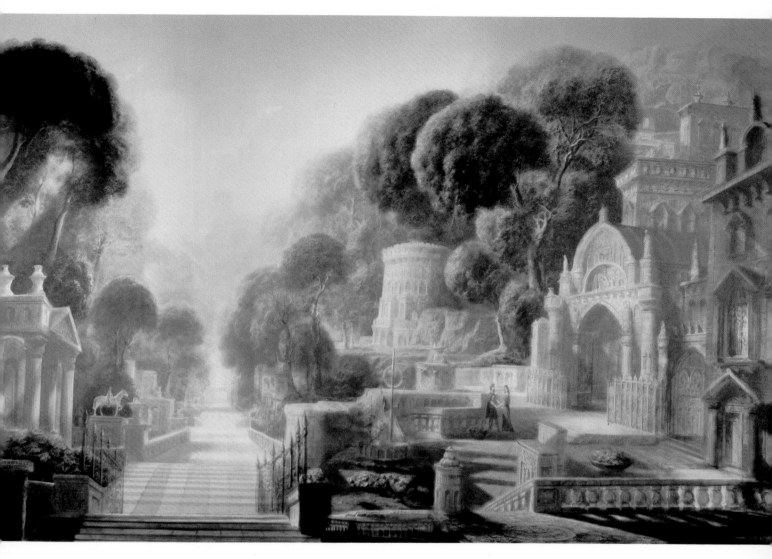

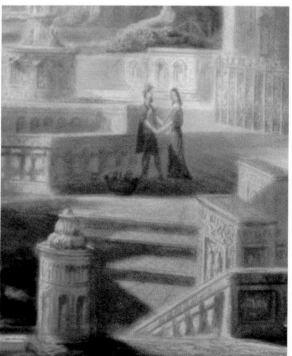

Plate 1: Palace of Charlemagne, *1976. 29″ × 43″ The extensive detailing is reminiscent of the Pre-Raphaelite technique. The illustration on page 74 (top) indicates the possible implications of the couple in the middle distance.*

(left) Detail of Plate 1

FORMATIVE EXPERIENCES · 33

Plate 2: Untitled, 1945. This painting was the one on which the "Boy" in 1946 made the prediction that Hitchcock would be "a light unto others."

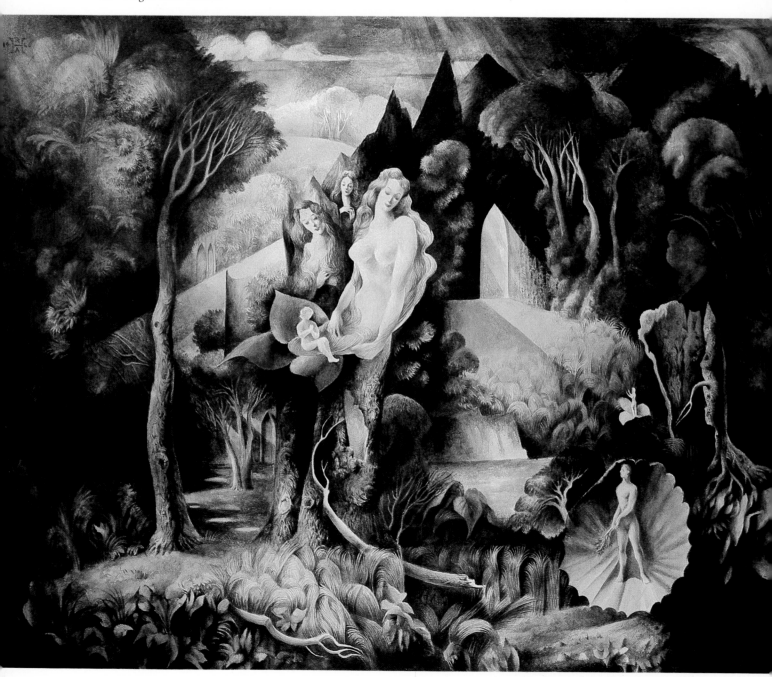

Plate 3: Untitled, 1973

(right) Detail of Plate 3

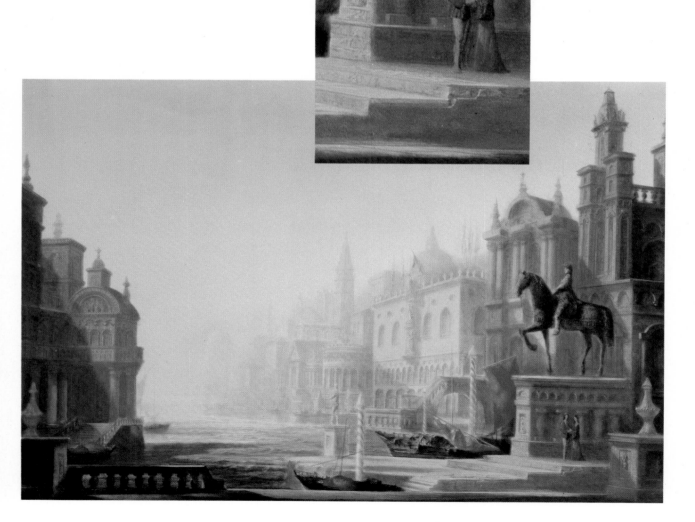

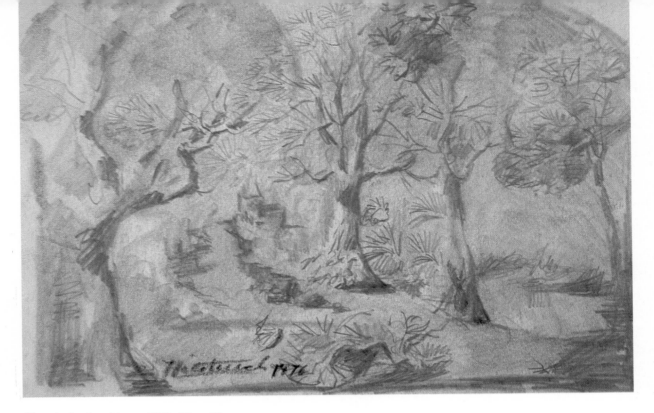

Plate 4: Study of trees, 1975. 7" × 9"

Plate 5: Untitled, 1973. 19½" × 28"

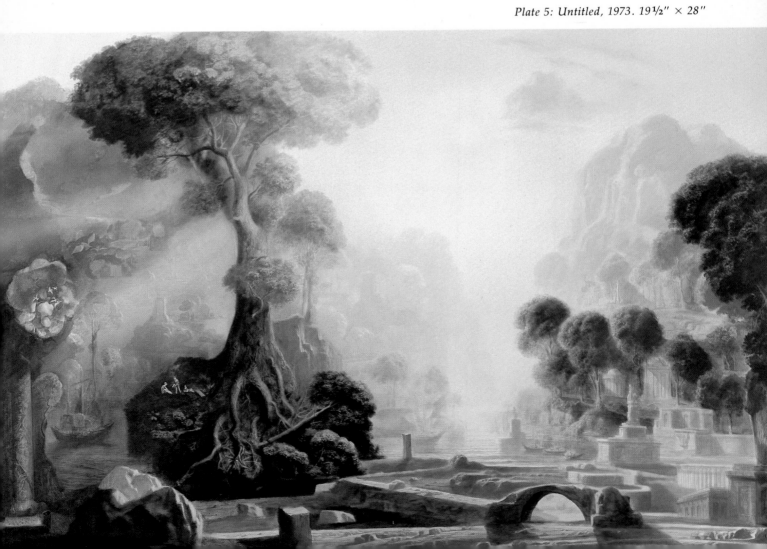

Plate 6: (below) **Sunrise in a Valley**, 1974. 40" × 60" *Oil on canvas. (left) Detail of Plate 6*

Plate 7: (overleaf) **Camelot**, 1969. 31½" × 43½" *This painting is strikingly similar, especially in its mystical overtones, to an early French version of the Celtic Arthurian legend. The young hero knight, Percival (Wagner's Parsifal), comes to a mysterious castle where, in a blinding light, a procession bears the Holy Grail, the supreme talisman of eternal life.*

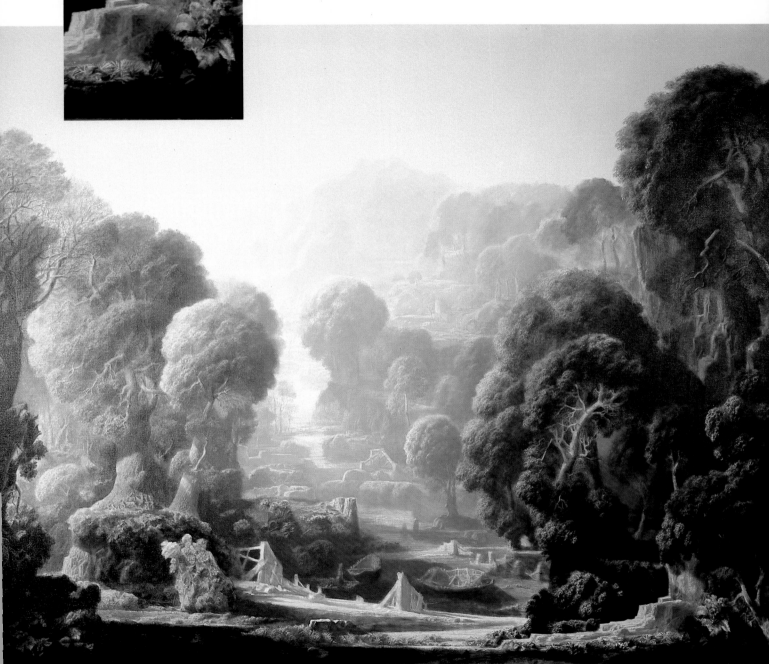

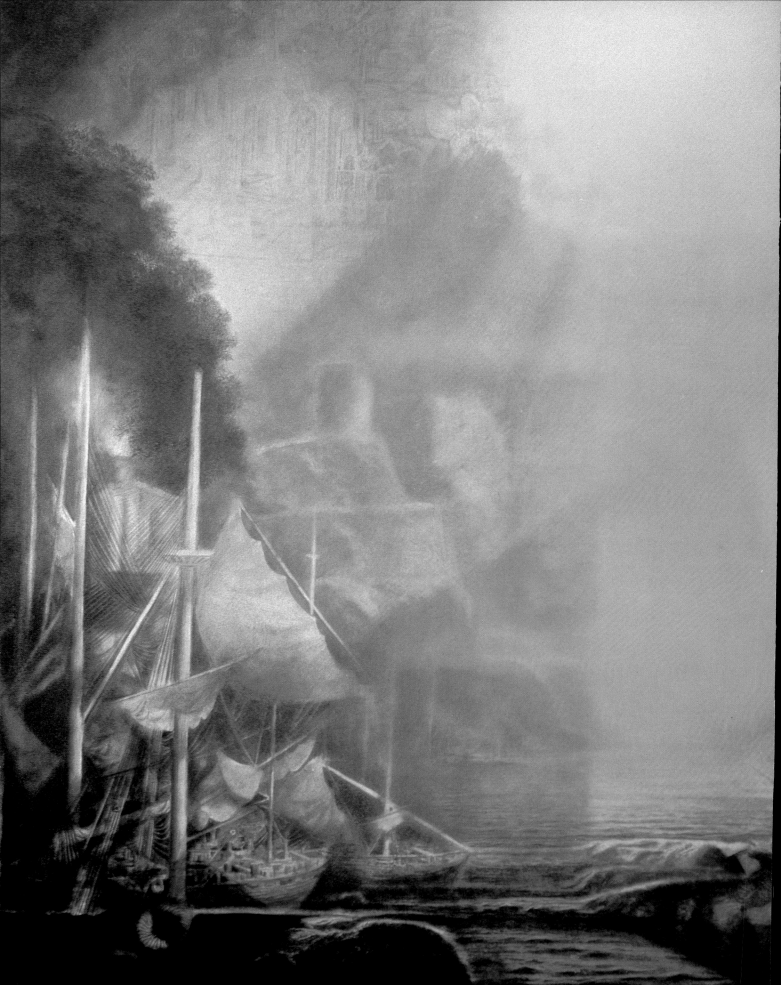

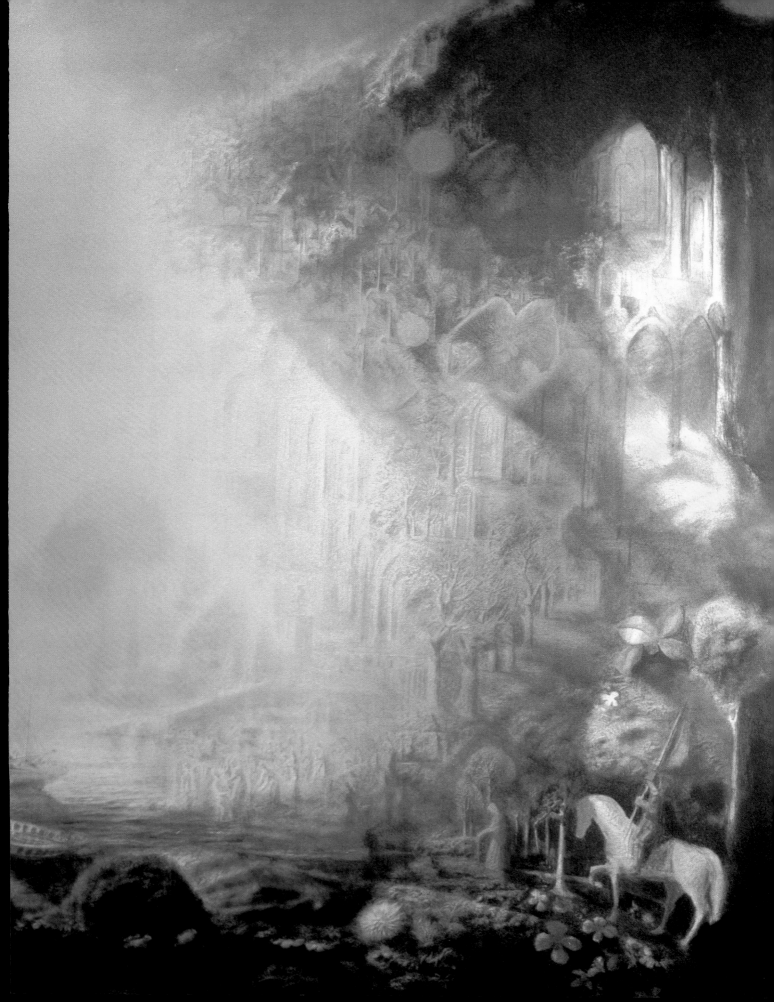

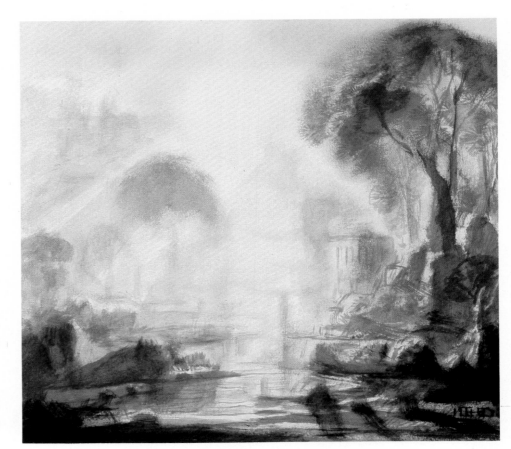

Plate 8: Untitled sketch, 1978. 9½″ × 10½″ The left side reveals the initial forms and light done with eyes closed, to which later detailing is added, as seen on the right.

Plate 9: **The Mill,** *1967. 30″ × 40″ Lidice Memorial Museum*

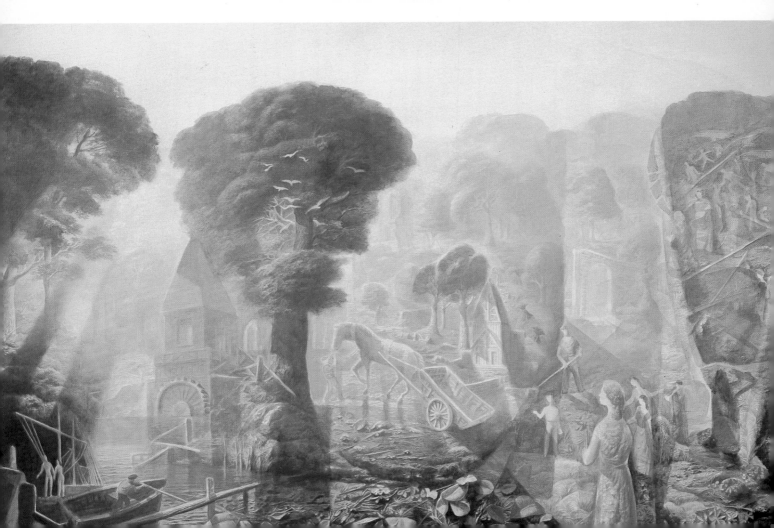

had lost that exalted feeling he had experienced at Thundersley. "It was as though a blanket had come over me. I have often thought that the way I felt then was the same as expulsion from the Garden of Eden." But he would again recapture the revelation of his youth and his work would consistently hark back to the ideal landscapes whose prototypical subject was that Old Testament garden (Plates 10 and 34). See also Kenneth Clark's conception of the Ideal Landscape, pages 102 and 104.

When working, Hitchcock is able to capture what he feels must have been the spirit in the Biblical garden that exemplifies the perfect environment.

The War Years

With the outbreak of war, Hitchcock declared himself a conscientious objector and was directed to noncombatant service. He volunteered for the highly dangerous work of bomb disposal and was posted to a unit of the Royal Engineers on the northeast coast. Because his commanding officer did not trust him, he was not sent to Arnhem with the British paratroops and thus escaped the fatal historic raid.

Paradoxically, it was the war that gave Hitchcock the first serious opportunity to paint creatively. Under the most adverse conditions possible, which one ordinarily would believe to be inimical to any creative process, the necessary milieu was provided for his first serious apprenticeship in watercolors.

The camp life was a great strain and so whenever possible, and especially on weekends, he would immerse himself in the serious business of painting. Watercolor, because it was portable, was the only practical medium at that time. From a technical standpoint, the foundation of his present method of painting grew out of his army experience. He said later, "I can only surmise that I desperately needed to escape from my surroundings, from my spiritual imprisonment."

While in the army Hitchcock started to develop symptoms of trigeminal neuralgia, or tic doloreux, which was to plague him until 1959. It is characterized by an extremely severe stabbing pain in the face, coming suddenly and without warning, and is notoriously difficult to treat. Accused of malingering, he had the good fortune to fall under the care of a gifted physician, a Dr. Tomlinson, who was able to make use of Hitchcock's paintings to help him understand the psychic condition of his patient.

One picture in particular, now in South Africa, which was given as a present to the physician, served this purpose. It was a typical Hitchcock landscape with trees and water, titled "Landscape with Figures." Sometime after receiving it, the doctor asked Hitchcock to examine his painting with the help of a magnifying glass. In the center were two robed, biblical figures engaged in conversation and on either side were huge trees in massive detail. The right side of the painting was Satanic in appearance. To the artist's amazement he discovered gruesome little figures and beasts lurking in the undergrowth. In color Plate 18 one can discern similar Satanic figures. These he had not consciously painted. Where the water-

color had run it had formed beautiful details, down to the studs in the armour they wore.

The left-hand side was idyllic, filled with serene figures and pastoral beauty. There were paths leading to the alternate sides of the painting, and the biblical figures in the middle ground stood as though they were debating which turn to take. The painting seemed symbolic of Hitchcock's life and proved to be another turning point in his career. Dr. Tomlinson affirmed that its correct title should have been "The Entrance to the Gates of Heaven and Hell."

The artist was most disturbed about the doctor's discovery, having no conscious knowledge of ever having painted the mysterious scene described. Intrigued by the symbolic significance of these paintings, this physician arranged for a forum of psychiatrists to view a number of Hitchcock's paintings in London. The majority held the opinion that the artist was a psychopath and would probably go insane. Dr. Alfred Torrie, a disciple of Jung, was the exception. He stated that Hitchcock's painting was an outlet and that as long as he continued painting, he could and would live a normal life. Dr. Torrie was to play an important part in the artist's life and development, giving him his first exposure to the general public at exhibition and introducing him to the Subud Brotherhood in 1958.

Hitchcock was also given advice about himself by Dr. Tomlinson which he did not heed at the time. He was told that he had great potential and should continue his extraordinary journey into painting, but he was not able to take advantage of this advice then because of the terrible pain of his affliction.

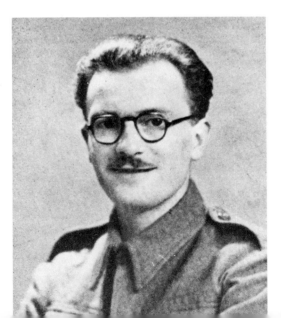

Private Hitchcock.

43

"The Boy"

While still in the army Hitchcock became interested in Theosophy. The term describes a religious philosophy with definite mystical concerns that can be traced back to the ancient world, but which is of catalytic significance in religious thought in the nineteenth and twentieth centuries. It is derived from the Greek *theos*, meaning *God*, and *sophia*, meaning *wisdom*, and is usually translated as *Divine Wisdom*. In modern times it has been identified with the doctrines of Madame Blavatsky, the Russian-born religious mystic. It refers to a certain strain of mystical thought found in such thinkers as the Greek philosopher Pythagoras (sixth century B.C.); Plato (fifth and fourth century B.C.); the Swiss Paracelsus, the Gnostic teacher, alchemist, and physician (1490–1541); and the German philosophers, Jacob Boehme (1575–1624) and Friedrich Schiller (1775–1854).

Whether ancient or modern, theosophical writers agreed that a deeper spiritual reality exists, and that man may establish direct contact with that reality through intuition, revelation, or meditation. They held that knowledge of Divine Wisdom gives access to the mysteries of nature, and of man's deeper being. The connection of Theosophy with Gnosticism seems particularly significant, since the latter had great influence on the early Christian fathers. The Gnostics regarded the material world as intrinsically evil, and believed that deliverance would come only through spiritual enlightenment. It should be noted that theosophical speculation has not been confined to Western thought; indeed, the richest and most profound source of such views can be found in India. While the theosophic content has been one among many currents in the West, it has been in the mainstream of Indian thought.

Hitchcock's first experience with mysticism came about when a young man serving in the army with the painter mentioned a friend of his father and suggested an introduction. The individual in question, apparently a most unusual person, a mystic, was an Englishman who had lived in India for some time. He had been born in the East End of London of very humble parents, and his home life had been appalling, due to his father's serious drinking. Consequently, he received practically no education whatsoever, and had to leave school before the age of fourteen and take whatever job came along.

In the course of his never-ending search for employment, he knocked on the door of a woman in the East End and asked if he could do any odd

jobs in her house. The reply was affirmative, and he came into the employment of this woman. It was she who gave the youth the nickname that stayed with him into adulthood and all through his life—she called him "the Boy."*

This woman, Swami Omananda Puri, herself on a high spiritual level, was well able to comprehend the strange sequence of events to which she was soon a witness. She subsequently wrote two books, *The Boy and the Brothers* (Doubleday, 1960) and *Toward the Mysteries* in which she explained how the Boy became a channel of communication for spiritual beings, the Brothers, who gave aid—often material—to persons in trouble.

After the youth had been with her a few weeks, his employer began to notice noises coming from the Boy's bedroom and went up to investigate. She observed him in a trance state, lying on the floor and talking in a cultured English accent that one would perhaps associate with royalty or with a person educated in a public school such as Eton. Normally his voice verged on the unintelligible, having a broad, rough Cockney cadence. This experience was repeated on innumerable occasions and the woman was able to observe him talking about man in relation to the universe, the cosmic nature of man, and about events of such a high order that she was astounded. How could this poverty-stricken illiterate from the East End of London possibly expound in such depth on such topics? It would take years of university study and worldly experience to encompass such philosophies. Then suddenly the Boy would revert to his Cockney accent, rub his eyes and wake up and be most apologetic for having drifted off to sleep.

*The name of the individual is known to the author; however, it is omitted by request of the artist.

The Meeting

Quite obviously the story of these events, as related to Hitchcock by his army friend, interested him. A meeting was arranged between this unusual fellow and the sensitive young artist struggling to find himself. Time would prove it to be probably the most important human encounter of Hitchcock's adult life.

Hitchcock vividly remembers coming up to London in 1946 with the young man through whom the introduction had been offered. They were to meet outside the Dominion Theatre in Tottenham Court Road at an appointed hour.

Hitchcock expected to see a pundit with an ascetic-looking face and flowing beard. Instead, he was confronted with a man in a cloth cap with a broad Cockney accent, wearing baggy old corduroy trousers. In appearance he was entirely the opposite of a person of deep spiritual insight and wisdom. Having expected a scholar of considerable erudition, Hitchcock felt most disappointed and thought there had to be some mistake.

He asked them to join him for a drink. After a short walk, they went into a cafe on Oxford Street. The events that followed are best described in the artist's own words:

As soon as we got into the cafe we sat down at a long table, myself opposite the Boy and my friend sitting by my side. There was also another man, a complete stranger, sharing the table on the same side as myself. The Boy took his cap off and put it on the table, and I shall always remember the feeling of awe that came over me, as though I was in the presence of a different being. A totally different being than I had been in the presence of a moment ago. I could not fathom why, but it is important to mention that from this point on I was to get to know this person over a period of time of six to eight weeks, and on every occasion he seemed different. I did not know then, but did subsequently learn twenty-five years later, that he was in a trance state on each of these occasions.

He began to ask me about myself and my work, and whether I was happy in what I was doing. My reply was quite simply that things were rather grim with my trigeminal neuralgia and lack of confidence in developing my own artistic style.

The advice I received was as follows: "You must realize that in this life one should accept and not kick against or resist feelings of pain. Rather accept them and try to understand the meaning of it, in other words, surrender and embrace this. In fact, I hope you go on suffering."

With that final statement, the stranger sitting beside Harold got up and demanded to know by what right he, the Boy, could justify telling anybody that his continuing to suffer would make him happy.

"You say I have no right to talk to this person in this manner, but you do not know the person I am talking to," the Boy answered. "If you knew him as long as I had and knew as much about him as I do, you would have a very different opinion." Hitchcock was most astonished by this last remark.

This was the commencement of a series of encounters over a period of eight weeks. Hitchcock met the Boy in the houses of different people, the majority of whom were very prominent in public life in England. To Hitchcock's amazement, the Boy was well known in the higher circles of society at that time.

On one memorable occasion, Sir Norman Birkett, QC, the eminent English barrister, was chastised by the Boy for attempting to cross-examine him as in a court of law, although the Boy had no way of knowing sir Norman's profession. Incognito though he was, Birkett could not conceal the tools of his trade from the Boy.

At one particular meeting he attended, Hitchcock was glancing at a print of one of his own works when the Boy asked if he might look at it. He looked at it, closed his eyes for quite a few seconds, suddenly turned, and looking at Hitchcock said, *Carry on painting. You are destined to be a light unto others.* (Plate 2 is reproduced from the actual print on which the Boy made his prophecy.)

Those prophetic words would prove true. From that time on the Boy took a particular interest in Hitchcock, showing a marvelous affection whenever he turned up at the meetings. In fact, Hitchcock was one of the last people to see him before his return to India. He helped him to pack the few worldly possessions he had, and from the moment Hitchcock said goodbye to this remarkable individual, he was haunted by the memory of him. Then in 1971, quite by chance, a biography of the Boy fell into his hands.

The one central fact that Hitchcock had been totally unaware of was that the whole of the Boy's life had been devoted to the trance state. He, the Boy, was merely the vehicle for transmission of esoteric teachings, according to *The Boy and the Brothers,* written by the woman who had originally befriended him in London and given him employment.

The Boy apparently developed considerable fame in India as well as in England. His teachings attracted countless numbers of philosophers, mystical swamis, and those seeking help. He became a revered figure and died in India in 1956. On his deathbed the Boy sought news of Hitchcock. As always, he was interested in practical human problems. He loved the young artist, so he fretted when he did not hear from him, and inquired amid the anguish of his dying hours whether there had been a letter.

In another book, *Toward the Mysteries,* one of the meetings that transpired between Hitchcock and the Boy is recounted as follows:

The following few notes are taken from a report of a talk with a young artist who had joined the Army on the outbreak of World War II. The young man told the Boy, "My heart is not in this work. I fear to become deadened, to lose my individuality."

"This need not occur. Remember, it is not what your heart is in, but what is in your heart that matters; whatever is in your heart will remain if you do not deny it. It is not necessary for it to be manifested under these military conditions. All that we ask of you is that you not forget or deny." The Boy smiled affectionately at the serious-faced youth and appealing to his philosophic nature uttered wisdom in the form of an enigmatic aphorism.

"From our point of view, there are only two kinds of good in the world: the good-for-nothing and the good." The young man was suffering much inwardly, his big artistic temperament aching for spiritual realization, and at times he became moody, irritable and discouraged. The Boy knew all this. "You cannot build harmony out of strife! If you build the raft of life out of wood it will sink in the ocean of degradation and mediocrity."

The Boy impressed upon him the virtue of patience and the necessity of the awareness of both good and evil within. The encounters Hitchcock had with this mystic named "the Boy," and from which we have only one tiny excerpt, presaged in remarkable fashion both the career and development of the artist. Thirty years later a psychological profile and testing of the artist corroborates to a considerable degree the more poetic analysis of 1946.

Hitchcock is described as being a man with a strong obsessive-compulsive aspect to his character. Even the casual observer of his work would have to concede that the minute detail and exactitude in his

technique bears witness to such a component. The obsessive element in his personality results in his being a profoundly deep thinker with a strong philosophical bent. A verbally and emotionally retiring man, he finds interpersonal relationships extremely painful at times because of his great emotional sensitivity. He is object-oriented rather than people oriented. His paintings are a natural release of his otherwise subliminated emotions and their conception is the result of his unique vision.

The obsessive-compulsive element in Hitchcock's work may have been inherited from his ancestor George Stubbs, who brought a new precision to animal painting. In Stubbs's day a penny would suffice to buy a carcass of a horse, which was painstakingly dissected and the precise anatomic details transferred to the canvas. I believe that Stubbs's treatise on the anatomy of the horse is still used as a standard reference for equine medicine.

After the war Hitchcock continued to work as a commercial artist in a business started by an acquaintance from the 30's. It was mechanical, soul destroying, and devoid of the creative freedom he sought as a goal and to which the Boy had been trying to lead him. His trigeminal neuralgia was intermittent, but with each occurrence the pain intensified.

In 1947 he had the first public showing of his work at the international art center at Ormond Square, Bayswater. This was arranged on the basis of a friendship established with Dr. Torrie, who then was a Brigadier General and Chief of Psychiatry of the Army. Torrie, who was a Jungian psychologist, had been immediately struck by the distinct quality of Hitchcock's work, even at this early stage, and also by its penetrating psychological implications. Torrie wrote: "Harold Hitchcock paints from the deep core of his personality, the inner, and goes to the root of all living things. His paintings show the roots of trees, reaching down to the source of life." A clear example is the painting reproduced on the dust cover of this volume. The poet Walter de la Mare saw Hitchcock's work at this time and was moved to express a considerable enchantment with it.

Until 1958, Hitchcock was plagued by his physical ailment and this finally culminated in his undergoing intracranial surgery. The operation was a complete success and afterwards, freed from his physical ailments, Hitchcock was able to begin painting again in a manner that had been denied him for many years. The release of his artistic potential was further

accelerated by his joining the spiritual brotherhood of Subud in 1960. Subud is not a religion, but its purpose is deeply religious and is based on spiritual experience. Its aim is that one worship God, care for one's fellow man, balance the material and the spiritual, and become a person of good moral character. Submission is the keystone of its philosophy, denoting an Eastern influence.

From this time on Hitchcock was to begin to realize his full potential as a uniquely creative artist. Liberated from his pain, he was able to submit to his inner calling, which was revealed and unveiled by the teachings of Subud.

In 1962 a number of his paintings were purchased by the author Paul Gallico, and in the years that followed a warm dialogue developed between the two men. The following message was written by Gallico:

> *The paintings of Harold Hitchcock are windows, opening out onto the world of wonderful dreams, magical forests of exotic trees, leaves and flowers, and of deep silences. There is a through-the-looking-glass wonderful quality about them that offers a haven to the weary spirit. When I am tired or dejected I go into mine, lean my elbows on the sill, and looking out, match my dreams and yearnings with his, for they come from the same source: the wish to be something better than we are, and to dwell where fantasy has supplanted reality.*

> *This artist, descendant of George Stubbs, paints his thoughts and his passionate feelings for nature engendered, when, as a small boy, he escaped the harsh angles of the city for the soft and beckoning contours of the country, where he went to live with an understanding grandfather who encouraged him to draw. But what he saw and felt of nature lay dormant until the middle of life, when suddenly the dreamscapes unplanned flowed from the subconscious to his canvases. Fingers hold the brush, but whither it will go, what forms will emerge not even Harold Hitchcock knows until it is done. It is this quality that makes him singular and his art an enchantment.*

In 1964 Hitchcock finally gave up his commercial work. The same year a number of his paintings were purchased by the Duke of Bedford and an imaginary rendering of Woburn was the product of a subsequent visit to the Duke's ancestral home, Woburn Abbey.

In 1965 a highly successful exhibition was held at Woburn Abbey,

(above) With the Duke of Bedford at a television interview in North Carolina during the American visit, 1970.

(left) The painter viewing his village.

attended by the cultural attachés of several nations. Subsequently a work entitled "The Mill" (Plate 9) was purchased by the Lidice Memorial Museum, and presented at a ceremony in the Czechoslovakian Embassy in London in 1967.

Hitchcock held his first major retrospective exhibition in the Royal Institute Galleries, Piccadilly, in 1967. In 1969 his first, successful, visit to the United States was arranged. He was accompanied by the Duke and Duchess of Bedford on an exhibition tour of a number of American cities. Many of his more recent paintings are now in the collections of prominent Americans. Their luminous tones are more intense than in his earlier work, heightening the beautiful effects of color, while always preserving the scintillating effects of light, sometimes veiled, sometimes crystalline.

In 1975 he underwent another major surgical operation for removal of an enlarged thyroid gland. The works of the artist throughout this period parallel the frightening experience he underwent. The broken tree in Plate 22 symbolizes his fractured spirit.

Now in excellent health, Harold Hitchcock lives at Ugborough in Devon, a southern county of England, with his wife Rose and their three children. The unique Saxon village he chose as his home, far removed from the insanity of the modern city, provides an ideal setting for his temperament. It is the only one of its kind in England; a pattern of six lanes leads symmetrically into the village square, dominated by a Saxon church. At midnight the haunting sounds of the striking church tower bell beckon one's thoughts to medieval times. It is curious to relate that this village lies along the ancient lay lines (drawn on maps) purported to be found at Glastonbury, seat of the ancient court of King Arthur. Along these lines, many of the legends of King Arthur occurred. Prior to learning these facts, Hitchcock had completed a series of fantasy land-and-seascapes on King Arthur and the Knights of the Round Table (Plates 7, 12, 13 and 20). The connection would appear to be stranger than coincidence, and it is such with Harold Hitchcock.

The essence of the man is humility and simplicity. He is a true innocent of the spirit; the hustle and bustle of modern life overwhelms him. He sustains the tradition of explaining life beyond the limits of reason. Let his paintings appeal to the eye, and for a moment we discover a new world, a world so different from our own that it seems a place of dreams and magic.

Part II
THE ARTIST

Pictorial Automatism

When confronted with Harold Hitchcock's work, the viewer is immediately and quite involuntarily drawn into the depth of the painting. The paintings possess atmospheric qualities achieved through a masterly handling of the effects of light; this in turn is attributable to his intuitive feeling for the complete spectrum of color tones appropriate to the subject matter. This technique is unique and has been the object of great speculation, to the extent that many critics flatly refuse to accept the artist's beguiling explanation. One prominent English critic, Hansi Bohn, said: "He claims never to plan his work, but to work spontaneously. This is clearly impossible in a technique where all the white and lightest tones have to be left out and their precise shapes and placings very accurately determined from the start and so on with every subsequent layer."

However, an invitation from the master to the skeptic has not been accepted. In essence the artist's technique had been described and advocated by André Breton in the first Surrealistic Manifesto written in 1924. He proposed that Surrealism was a means of reuniting conscious and unconscious realms of experience so completely that the world of dream and fantasy would be joined to the everyday rational world in "an absolute reality, a surreality." Breton recognized a language essentially drawn from the unconscious in the writings of the Count of Lautréamont, and viewed the unconscious as the wellspring of the imagination, defining genius in terms of accessibility to this world. Romanticism and Symbolism had attempted to tap the same source. Breton advocated the commitment to paper of the immediate thought or feeling without conscious mental control, automatic writing, as it was called. He postulated that this would draw on the poetic stream unencumbered by the intellect and that ultimately the discovery of the purely "inner subject" would be the salvation of art.

Automatism was born of poetry but soon overflowed the narrow confines of literary expression into the visual arts. The works of André Masson, Max Ernst, and Joan Miro exemplified his statement. Twenty years would elapse before Breton declared that "absolute automatism has appeared on the visual plane," a remark prompted by his encountering the paintings of Oscar Dominguez, a Spanish contemporary of Dali. This "pictorial automatism" as Breton described it was the mature surrealistic art form he sought.

The work of Harold Hitchcock fulfills with unequaled purity pictorial automatism in both its technical and philosophical aspects. Without preliminary drawing or sketches, and frequently with his eyes closed, the artist submits himself to the inner feeling, allowing his visions to emerge. See Plate 8, with its right side detailed, its left side unfinished. He is capable of repeatedly freeing himself and for a time utters profound truths from within, silhouettes of the inner man. The initial form that it takes is a feeling, and the hand is only an instrument used to produce a scene of visual splendor—a true metamorphosis of feeling into medieval fantasy. Nothing other than Hitchcock's inner self could dictate his hypnotic compositions. He is essentially a self-taught artist.

Hitchcock never works out-of-doors, and only paints when his studio is lit by the light of day. Customarily, after rising, he breakfasts leisurely and goes upstairs to his studio around 9:00 to 9:30. The studio has a large window which overlooks an abandoned farm building and beyond there is a large expanse of hilly pasture leading in the distance to the wild upland area of Dartmoor. In winter, a space heater is lit to take the chill off the air, and classical music turned on to provide the necessary mood. An esthete expecting to see a sophisticated palette will receive a rude surprise. Hitchcock's palette consists of standard watercolor pigments squeezed on the evening paper of the preceding day. He avows that the *Daily Telegraph* provides precisely the correct consistency and fluidity for preparing his washes. Such heresy, I am sure, would cause many an academician to turn in his grave.

When confronted with a blank board, Hitchcock just has to sit down and let his feelings dictate how he must start. Sometimes he simply starts painting in the top left- or right-hand corner, and the onlooker watches in amazement as the work takes shape on the white board as though the artist is stripping a blank cover from the finished painting. These beginnings often generate additional feeling, but at th inception his eyes are closed and he does not perceive a visual image. Slowly, as the painting progresses, he does begin to see forms emerging, but initially he is driven to paint by a feeling. His color is purely intuitive and unplanned. Again, it is feeling that dictates placing warm tones adjacent to cold ones.

He is always conscious of light and the need to reproduce its sparkle. He feels compelled to record the play of light on objects even to the minutest detail. This is the strongest single element in his paintings and

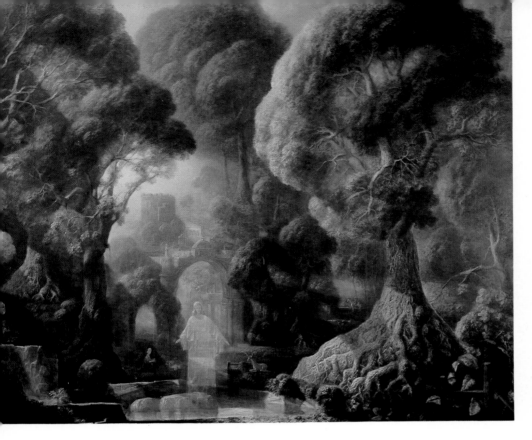

Plate 10: Pax Vobiscum, *1980. 48″ × 60″ A small boy holds flowers in a pose of supplication, as in Plate 18. Christ, the Good Shepherd, welcomes us to an enchanted forest where he is joined by a stag and a knight on horseback. The stag's symbolism of self-renewal or rejuvenation presumably arises, according to Jung, from his act of shedding antlers and regrowing them thereafter.*

Plate 11: A Harbor Greeting, *1978. 29⅜″ × 43½″*

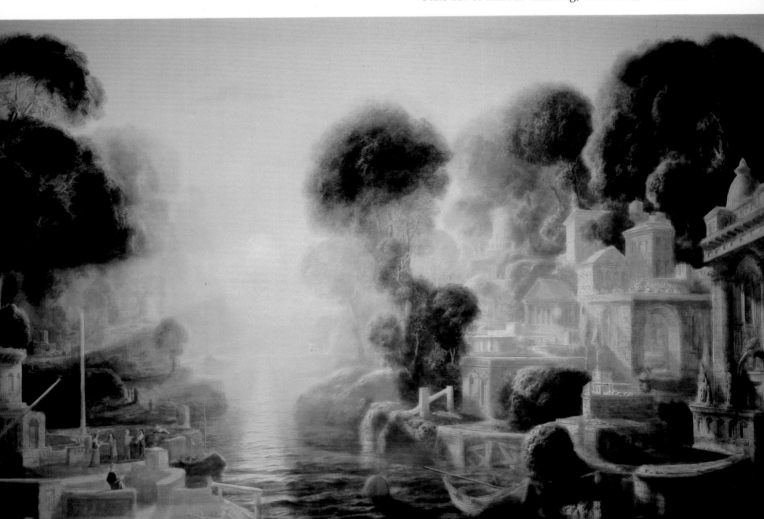

Plate 12: Untitled, 1974. The symbolic figure of the knight on horseback with lance is a recurrent Arthurian motif in Hitchcock's work, idealizing the aspirations of honesty and purity of soul.

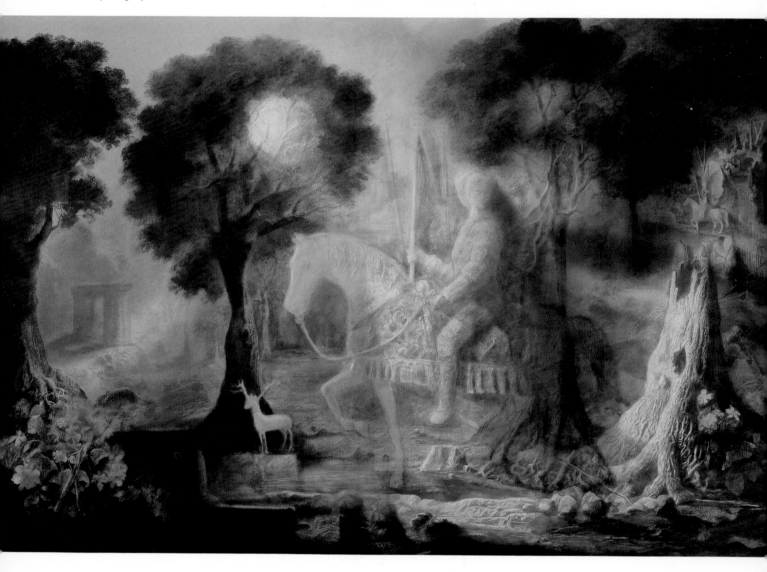

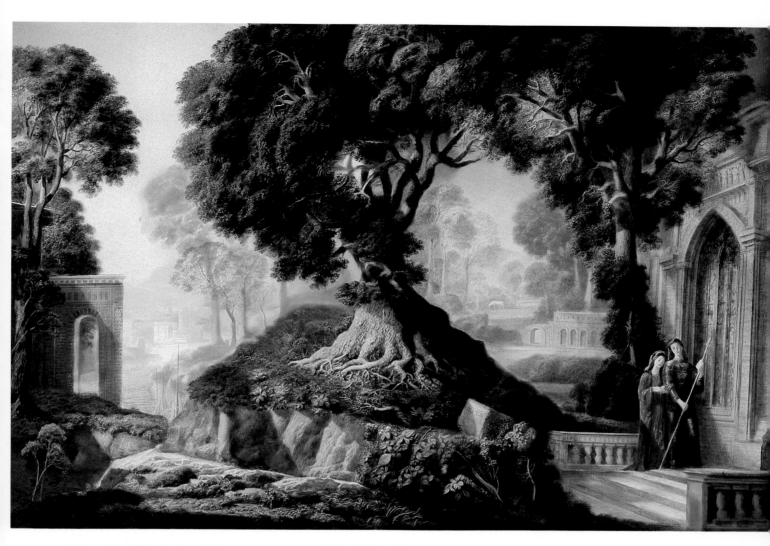

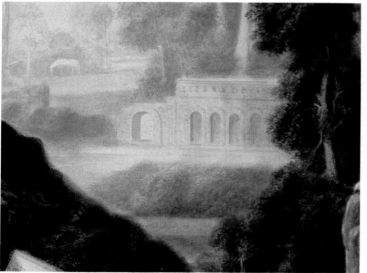

Plate 13: (above) **Arthur and Guinevere,** *1971. 30″ × 40″ Oil on canvas. (left) Detail of Plate 13*

Plate 14: (overleaf) **Sea Mist,** *1976. 29″ × 43″ This painting is evocative of J.M.W. Turner's portrayal of nature's atmosphere and light.*

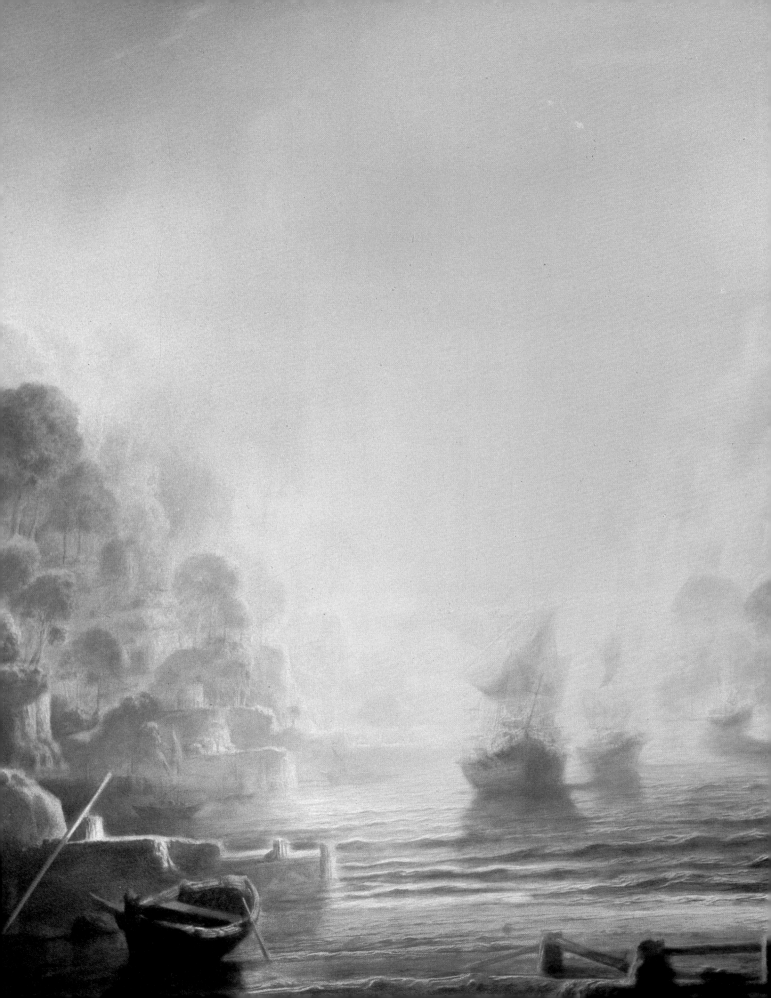

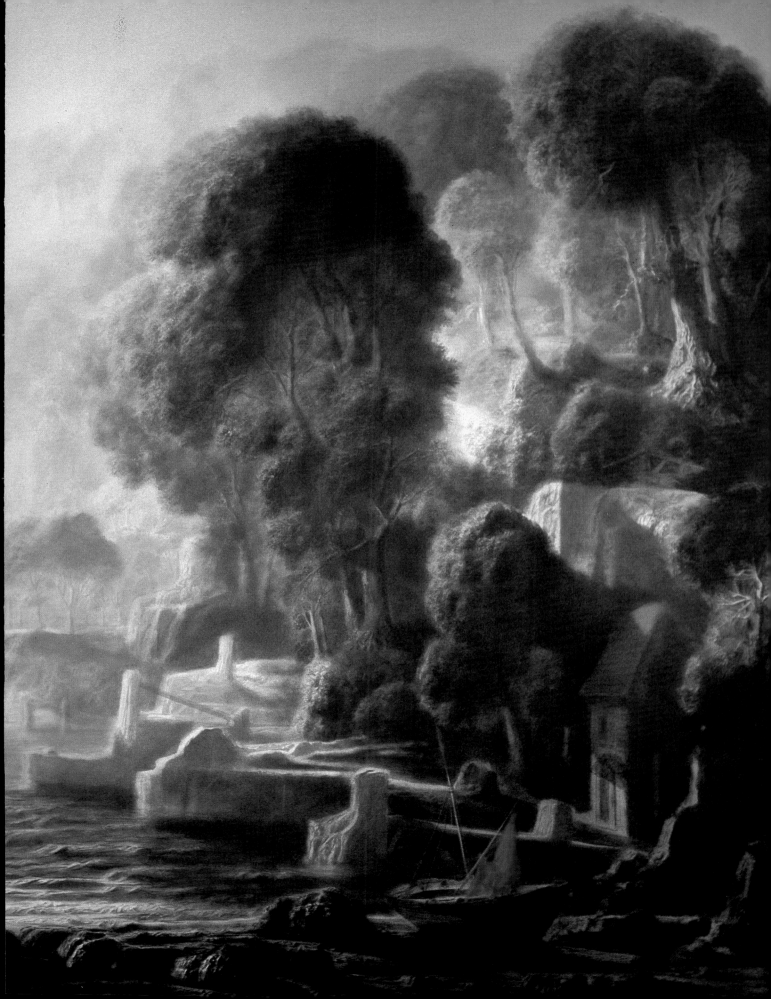

Plate 15: (below) **Venetian Lagoon**, *1979. 17″ × 28½″.*
Note the anchor in the right foreground.

(right) Detail of Plate 15

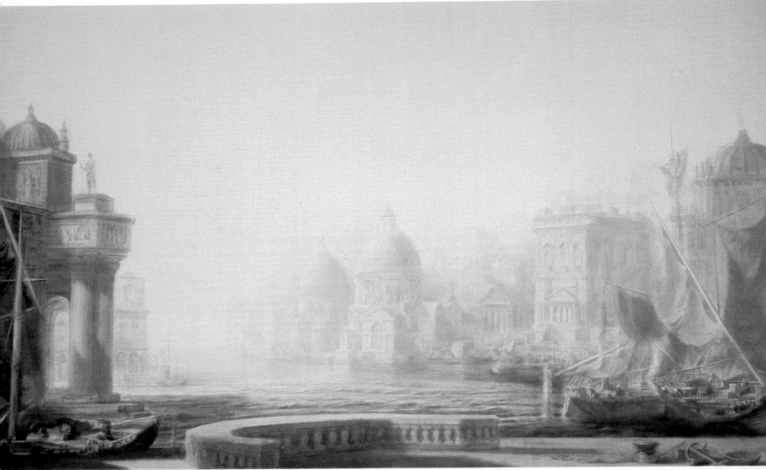

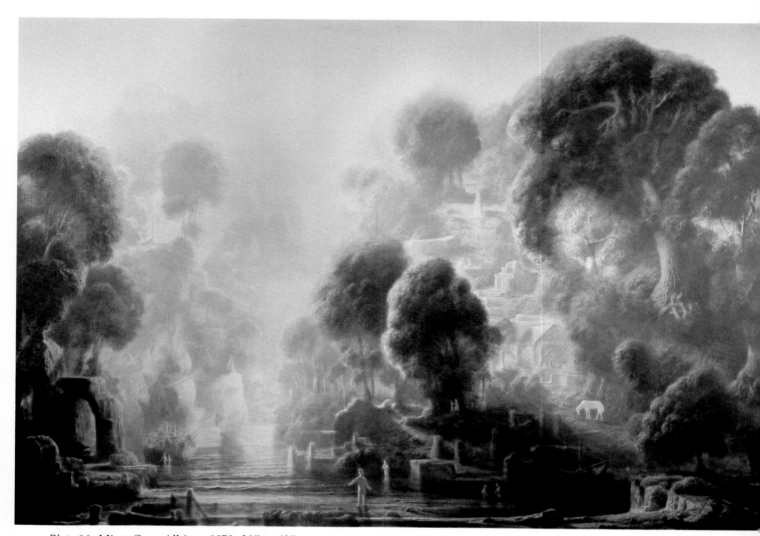

Plate 16: Mists Over Albion, *1979. 29″ × 43″*

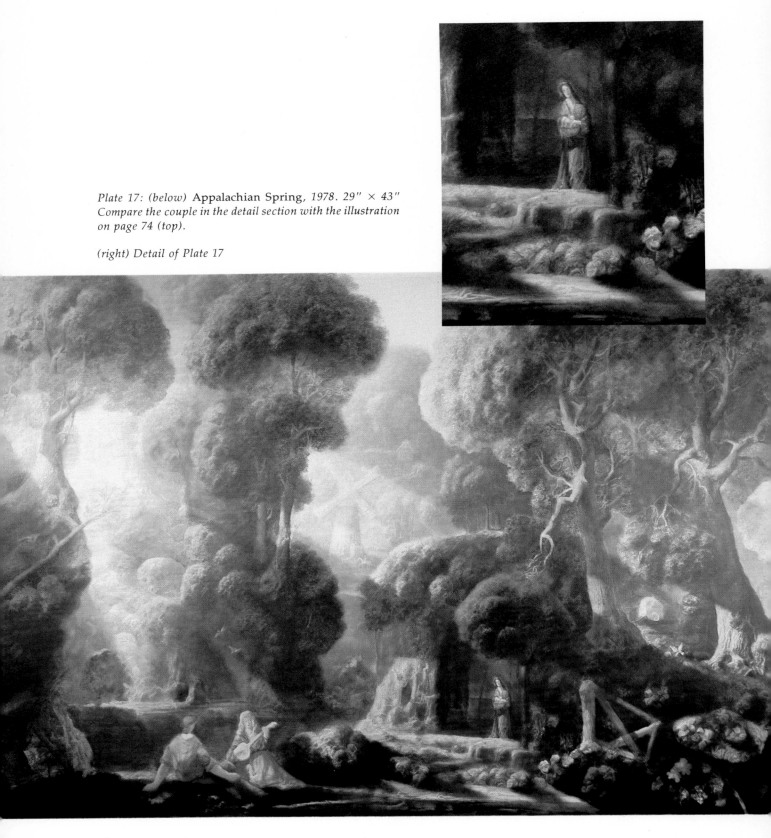

Plate 17: (below) **Appalachian Spring**, *1978. 29″ × 43″ Compare the couple in the detail section with the illustration on page 74 (top).*

(right) Detail of Plate 17

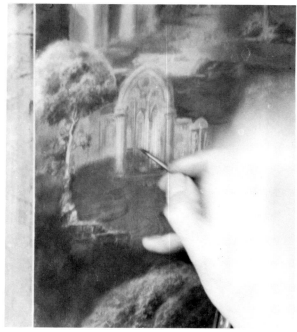

hearkens back to Thundersley, when he observed the sparkling jewel-like effect of light on the giant elm trees (Plates 27 and 28). He would go as far as to say that the subject matter, or content of his paintings, is in many ways secondary to the necessity for light. Whatever he paints must reflect this feeling of light which, in itself, is a unifying force in his paintings, and without which his work fails in composition.

(above left) Hitchcock painting in his studio.

(above right) Adding detail.

When asked about his unusual secondary colors, he simply points out that they are probably due to a combination of the lack of use of body color and the light of the ground showing through from his board. He builds up from very pale to darker washes, and the reason there may be a great variation in the shades of his colors is due to this light showing through from the ground.

The watercolor pigments he uses are quite conventional, but he has the ability to work in a range of washes from the palest to the very darkest, and it is this feeling for the whole spectrum of tonalities and intensities that differentiates him from other watercolorists. He does occasionally mix his watercolors with acrylic to give added body and intensity.

Again it is a question of feeling; one has to feel the range of light. The ability to reproduce intense light effects in a painting must depend on the secondary and dark tones. Unless one can work in the whole scale of tones from the lightest to the darkest, the effects of light will not be so obvious. Hitchcock uses ordinary watercolor pigments, occasionally mixing them with acrylic, but uses them in more intense form than is customary. He works in a manner almost the reverse of an artist using oils. He does not put down highlights with a heavy impasto, using white to lighten the

work. His paintings are first elaborated in secondary tones and then built up to the darkest tones, layer upon layer, which enables him to achieve the translucency, crispness of detail, and great depth characteristic of his work. When he tries to work in reverse, in the traditional manner, there is a certain deadness in his work. The brightness and life seem to have gone.

Hitchcock's work is built up around the light. When he paints a figure or a tree, he builds the shade and darker tones up around the light falling on the object, giving a greater intensity and depth. Working in darker tones necessitates considerable confidence and technical virtuosity, because alterations are virtually impossible.

His work is firstly luminous and mystical. The plunging perspective in multiple planes seems in proportion, but is totally unreal. We behold beautiful medieval settings with knights in armour on white steeds; solitary couples in magical forests; pastoral scenes and seascapes whose presence range in time from King Arthur to the days of the Middle Ages, and even back to the Phoenicians. The exquisite precision and attention to detail approaches the Pre-Raphaelite tradition (Plates 1 and 30) in vitality and freshness of expression, but the Pre-Raphaelites' total abandonment of atmospheric perspective in order to achieve the superclarity of the dream state is not a characteristic of Hitchcock's work.

One overlooks the rational flaws in his work, because, like a great work of fiction, it is totally convincing. It is like seeing a still from a spectacular historical film. The dramatic mood is variously heroic, pastoral, or biblical, depending on the subject matter and the emotive use of color.

Some of his works are executed in delicate schemes of blue, magenta, and orange; others, in rich earth tones of reddish brown, or clear greens and yellows. The clarity and lucidity with which he captures the essence of natural detail in trees, water, and atmosphere makes one aware of the wide-ranging sympathy and understanding that Hitchcock has for nature. His mature works embrace a gamut of coloristic and tonal variety, and the breadth and skill of his evocation of atmosphere attain great subtlety and complexity.

Yet another aspect of his work is the multitude of mysterious stories which mushroom at every turn about his paintings. Strange creatures appear and are seen in bushes (Plate 18); primitive animals leap from the

undergrowth (Plate 22); human faces of a bygone age peer from the bark of his primal trees (Plates 7 and 22). It seems that he has the power, through his paintings, to ignite the dormant world of people's fantasies.

The bizarre effects of Hitchcock's works on the viewer are best described by an occurrence which happened to William Wright, a BBC producer, who bought one of his paintings in London.

My wife and I decided that we wanted to buy a painting of an artist living in Hampstead who produced work of a beautiful, but strange mystical quality. We went to an exhibition of his work at a gallery and while perusing the paintings, fell in love with one particular one. It was hung high on the wall in the corner of the gallery. I was attracted to this painting from the moment I saw it. I tried to look at it more carefully, but it was hung rather high, and it was difficult to make out all the detail. In the foreground of the painting I could see four figures standing on a grassy bank; behind them stretched a typical Hitchcock landscape, the trees being permeated with a golden light that spilled onto a grassy bank. The figures were holding hands and seemed to be beckoning one to explore deeper into this world of fantasy. We decided to buy and eagerly awaited the end of the exhibition for the painting.

That very night I was to have the most profound experience of my life. An experience, no doubt, that could be explained away in terms of the subconscious. But that would be to dismiss the experience with too plausible an explanation. Let me tell you about it. I had, over the past years, been practicing a deep form of relaxation which had been of great help to me in times of stress.

After I had been in bed for awhile, I had the feeling that I had come downstairs to the lounge, and I usually relaxed in this way in my favorite armchair which I proceeded to do. Looking across to the other side of the room, I suddenly realized that the painting was there. It was hanging in the place we had picked for it. The frame, a heavy gilt one, was not the one it had sported in the gallery.

As I continued to look, I suddenly felt that the painting was becoming larger, or was it that I was becoming smaller? Whichever way it was, I found myself moving towards the painting. On reaching the little low table that normally stands on that side of the room, I found that it towered above me. Something seemed to be drawing me on, and I began to climb with some difficulty onto the table. I reached up towards the frame of the

painting, but it was well out of my reach. I looked around to find some means by which I could reach up to the painting. I thrust my hand into my trouser pockets and found a length of string. Without much ado, I began to throw the string above my head in an attempt to attach it to one of the protrusions of the gilt frame. All this seemed to be the most natural thing in the world to do. I had ceased to wonder why I had become so small or for what reason I was being driven to reach the painting.

The string, after several attempts, caught onto the frame. I tugged it until it was taut and I began to climb. The string held my weight without any bother, but I soon found the palms of my hand becoming roughened, not by string, but by what had become stout rope. I began to climb. It was hard going, and I soon was sweating from every pore. I bumped heavily against what now seemed to be the face of a cliff, but on looking up I could still see the gilt frame and the end of the rope disappearing over its edge. I continued to climb, and after what seemed an eternity, I reached the edge of the frame, and with the last desperate heave, I scrambled over the edge to fall face-downwards onto the lush carpet of grass, gasping for air. The color of the grass was brilliant green. It felt damp to my body. My hands gripped the grass as I lay there, and the smell of the crushed blades had something of the same effect as drinking champagne, a heady, wonderful feeling. I felt I had climbed into paradise.

After having lain there for sometime, I heard voices: "Have you found him yet? I'm sure he must be somewhere." On looking up I could see three people approaching me, two women and one man. They were not really people. They were rather like cardboard cutouts, faceless people. There was nothing hard about them. They were, in fact, the people Harold Hitchcock had painted in his work. One of the women I remember was wearing a red jumper. As they came nearer, the fact that there were only three began to register with me, because you will remember there were four figures in the painting.

"Here he is," said one of them. I'm not sure which had spoken or how, because they were still faceless. I was helped to my feet and we all now began to walk over the grass towards a forest glade. The trees and the light coming through their branches and the grass underfoot— everything about the scene—seemed to breathe a kind of peace I had never known before.

Where is that smoke coming from? I hadn't noticed it in the painting." It now seems an odd question. I could see a thin wisp of smoke rising out of the green valley in front of me and gently rising to the sky.

Well, you wouldn't see it in the painting, it would be hidden from view by the hill we have just walked over." Again, I am not sure which one of these strange companions had spoken.

Time seemed to come to a halt. The four of us talked endlessly, but I cannot remember in detail much of the conversation, and yet it seemed that a whole lifetime was being spent in their surroundings. No thoughts of hunger, thirst, or fatigue crossed my mind. At one stage of this remarkable dream, for what else could it have been, I asked, "Where have you come from?" "Another dimension. We wanted to come into the painting as you have wanted to, too."

I realized that these faceless people were not of my world, and yet we had all desired to find this paradise, for there is no doubt in my mind that this is where we were. Towards the end of the dream my companions informed me that they had to return from whence they had come. A man and one of the women left. Remaining with me was the woman in the red jumper, still having a faceless appearance. I asked her where she was going and she replied, "Across the lake in the boat." Perhaps it would be truer to say that I knew this is what she intended for there was no word uttered by her in the conventional way.

Almost as she said she was going, I found myself quite alone. In this strange but happy place, the thought occurred to me that although this was a dream, I must remember as much detail as possible. But this was not the end of the story. I told a few friends about it, and most of them seemed fascinated by the tale.

On collecting the painting from the gallery I was amazed to find that there was nestling between two small hills in the painting a tiny lake across which the woman had said she was returning. A feature which would have been impossible to have seen when the painting was hanging high in the gallery.

The painting gives us great pleasure as it hangs on the wall of our home, and as I sit gazing at it, I often wonder whether the three figures standing there are still waiting for their fourth companion to join them once again.

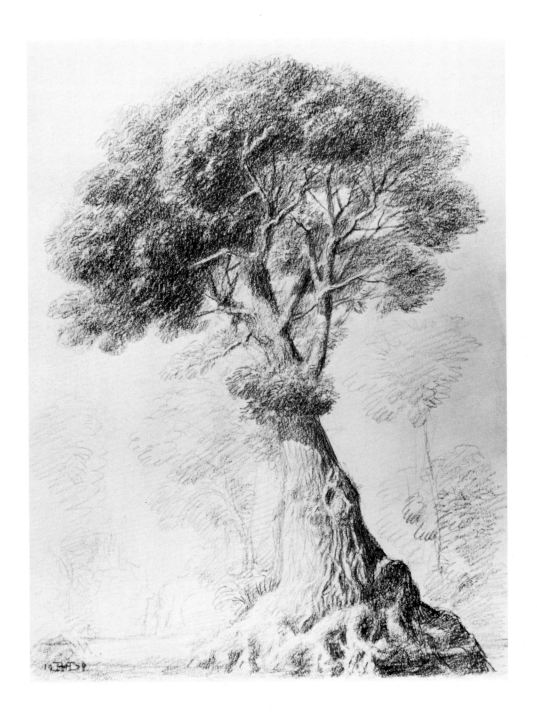

Strange as the story may sound, the experience is not at all a singular one. Hitchcock's paintings appear to activate individuals' unconscious, and put them in touch with their hidden world of fantasy. In modern society, replete with materialism and spiritually bankrupt, this quality has become an invaluable asset.

Insofar as it is possible to distinguish between the forms of a work

of art and the spirit that infuses it, it is perhaps true to say that the spirit of Hitchcock's art is reminiscent of Claude Lorrain (Plates 11 and 23) and the Pre-Raphaelites (Plates 1 and 32), but the form is of an originality rarely equaled. He has evolved a system of thought and fantasy which is unique. Poetic and moving in its intensity, it is a product in part of inheritance, and in part of social circumstances. It is language for the communication of his inner spiritual peace. In these poetic fantasy land-scapes inspired by his childhood memories, nature is not lost; it is transformed by the imagery of his subconscious into a new form.

This is his gift, a new form expressing how one individual feels and loves nature. His process of expression is essentially a lyrical one, a visual confession of the soul which is full to the brim, and which, true to its nature, unburdens itself through symbolic imagery, just as a poet expresses himself through the written and spoken word.

Hitchcock touches off within each one of us a universal truth: that childhood memories evoked in adult life are among the sweetest. He recalls us to our own fantasies, rekindling those memories we vaguely understand. His paintings, over and above their visual beauty and brilliant draftsmanship, stir within us a sense of wonder. Theirs is a world we cannot logically explain, yet their incomparable attraction prompts the eye to marvel and return for more understanding.

Simply stated, his works have such innocence, charm, and numinosity that, standing in stark contrast to the complex intellectual world in which we live, they provide us with an escape.

The term automatism is a description in words of a technique of painting in the visual arts which has as its driving force the unconscious mind. The technique itself and its various effects have been briefly touched upon. In the following chapter some other aspects of Harold Hitchcock's art are considered in relation to ancient mythology and symbolism, all as expressions of the collective unconscious. This approach is in accordance with the views of the art historian Aby Warburg, who contended that paintings should be regarded as symbols, and that the origin, meaning, and transmission of symbolic visual images is of primary importance.

The Collective Unconscious

Strange are the ways by which genius is announced, for what distinguishes so supremely endowed a being is that, for all the freedom of his life and the clarity of his thought, he is everywhere hemmed round and prevailed upon by the unconscious, the mysterious God within him—he knows not whence; he is driven to work and create—he knows not to what end; and is mastered by an impulse for constant growth and development—he knows not whither.

K. G. CARUS

The preceding evaluation and explanation of the technical aspects of Hitchcock's painting and its relationship to the classical surrealistic concept necessitates, in order to be more complete, a more detailed look into the source of the artistic inspiration—the unconscious. Harold Hitchcock is an artist who despaired of the twentieth century he must inhabit, who realized he could not survive using its values, and therefore strove to find his own meaning for his existence. Giant scientific strides may occur, providing jobs and creature comforts, but instinctively Hitchcock knew that they by themselves would destroy his raison d'être. He clung to the memory of Thundersley, tenaciously and laboriously seeking to recapture its meaning—that one moment of ecstasy.

Every artist's individual form of expression is influenced by his journey through life. Hitchcock's singularly most significant moments were his childhood experiences at Thundersley, but not until adulthood was he able to attain a spiritual philosophy commensurate with his inner feelings.

The majority of mankind averts its eyes from the frightening things that lie beneath the surface of our consciousness. Artists throughout the ages have sometimes dared to touch on these forbidden grounds, creating haunting depictions of our deepest fears. The unconscious was the fount of their artistic expression. This also applies to the work of Harold Hitchcock. However, contrary to the work of most artists before him, the imaginary world he depicts does not tap man's darkest fears, but his primitive loves.

His work stirs within us an echo of the feeling of joy and mystery the artist experienced as a child, and his greatness may prove in time to be his ability to remind us of that collective human experience. In an increasingly technological era he makes us marvel and wonder beyond

the simple limits of his technical mastery, awakening a feeling for nature dormant within us all. The psychologist Dr. Carl Jung expressed in his book *Memories, Dreams and Reflections* what Hitchcock visually realized some years later:

> *The earthly manifestations of "God's world" began with the realm of plants as a direct communication from it. Plants were bound for good or ill to their places. They expressed not only the beauty but also the thoughts of God's world, with no intent of their own and without deviation. Trees in particular were mysterious and seemed to me direct embodiments of the incomprehensible meaning of life. For that reason the woods were the place where I felt closest to its deepest meaning and to its awe-inspiring workings. (Plates 18 and 4, and on page 70)*

Jung had experienced in childhood, as Hitchcock had, "the incomprehensible meaning of life" communicated to him by trees—the giant elm tree sparkling and dancing in the morning sunlight. In one magical moment, Hitchcock had fled the confines of a purely earthly existence for the spiritual world he intuitively knew would grant him peace, harmony, and joy. His realization of the overwhelming beauty of nature and his universal love for all things in nature, particularly the effects of light, gave him kinships of a different order than that with Homo sapiens and the confining world of man alone. The painting that depicts the unusual incident at Thundersley is best understood once the viewer

A prehistoric painting from the caves at Lascaux, France, showing a bird and a shaman as symbols of transcendence. Centre d'Études et de Documentation Prehistorique, Toulouse, France.

A crowned hermaphrodite from a 17th-century alchemist's manuscript, symbolizing our inner duality and the desirability of a conjunction of the opposites in life. The alchemists' experiments with turning base metals into gold were in reality motivated by an unconscious search for inner harmony and unity. This motif recurs in a number of the paintings (Plates 1, 13, 17, 21 and 22), producing a particular type of symbol, a mandala, as a result of his process of individuation. A verbal example is the poem by Blake on page 92. Leyden University Library, Leiden, Holland.

Pluto and Persephone holding plants as symbols of seeds buried in the earth and reborn from it. The attitude is one of supplication. The ancient mystery religions were rooted in the art of agriculture, with a central focus on nature's eternal cycle of birth and death, and also with the burial of seed in the earth. The parallel with life after death for human beings is obvious and this becomes a central theme of the Elusinian mysteries. The pose of the figures is a ritualistic one. Scala/Editorial Photocolor Archives.

becomes aware of the many symbols incorporated within it (Plate 18). These symbols, used by man for thousands of years, can be discovered in the cave drawings of Lascaux, France, and in the works of artists and craftsmen from Egyptian and Greco-Roman civilizations to the present era. Unlocking the power and meaning of the symbols spontaneously produced by the artist's psyche lends another dimension to his statement. The profound feeling of beauty, peace, and mystery experienced by so many when confronted with his work is not diminished by a lack of knowledge of symbolism. Those who do care to investigate will be better able to understand the inner feelings communicated by the artist through the medium of his work.

Hitchcock's original experience as a child at Thundersley was, in psychological terms, one of transcendence. This can be defined as a state of mental well-being characterized by feelings of ecstasy and exhilaration and induced by the individual's experiencing a sense of release from one confined pattern of existence to a superior one. States of transcendence are often represented symbolically by a solitary journey or pilgrimage. Examples of this can be found in numerous literary works like Dante's *Divine Comedy* or John Bunyan's *Pilgrim's Progress.*

The mind of modern man is comprised of two components: an unconscious and a conscious element. As the latter emerged over a period of ages, man increasingly separated himself from his basic instincts, which reside in the unconscious. However, these have not disappeared and it would be unreasonable to assume that each newborn being invents or creates its own instincts. The human equivalent to the instincts of animals is referred to in psychological terms as *archetypes,* a tendency to form certain patterns of thought, behavior, or symbolic visual patterns. These archetypes are, like the animals' instincts, innate and inherited, and as the human body is structured after the general anatomical pattern of the mammal so the human mind is built around an ancient psyche.

The progress of the human race manifests itself in the apparent evolution of man's physical appearance; simultaneously, the mind has undergone a parallel process of evolution, and much of modern man's unconscious mind resembles products of our ancient psyche. These vestigial remnants of the ancient mind are what Jung calls the *archetypal images.*

The manifestation of archetypes into behavior patterns is drawn from what Dr. Jung describes as the collective unconscious and to quote him: "It is that part of the psyche that retains and transmits the common psychological inheritance of mankind. In addition, man's inner religious drives are at least as strong as any of his other hidden urges and each person is influenced not only by his personal experience, but also by the collective experience of the whole human race."

The unconscious archetypal images of man are as instinctive as their counterparts in the animal kingdom: the migration of caribou, the homing of pigeons, or the elaborate spring spawning dance of the grunion. Grafted onto the structure of instinctual behavior is man's world of conscious rational thought. The former produces feelings, passions, and gifts of great imagination; the latter, logical thought and the propensity for adaptability.

Modern man is still driven by the same powerful forces that have animated his existence for hundreds of thousands of years. In today's highly rationalized world these forces, the archetypes, when permitted to arise from the unconscious, present not only an almost limitless source of artistic inspiration, but also a means of furthering the comprehension of oneself.

It can be a traumatic experience for man to realize his dependency upon powers beyond his control, propelling him at an increasingly frenetic pace to seek meaning and direction in life. His superstitions, gods, and demons have not disappeared. An insatiable desire for alcohol, drugs, and tobacco, and the increasing incidence of psychosomatic disorders and neuroses are the external manifestations of this denial. In this respect dreams are messages from the instructive unconscious to the rational conscious parts of the human mind, and their relevance as symbolic images is being increasingly recognized.

Besides functioning as a repository of basic instincts and repressed conscious thought, the unconscious has an even more vital function—a source of great creativity and imagination. When rational knowledge has reached its narrow limits, the unconscious steps into the often terrifying void of the inexplicable, filling it with rich imaginative solutions to the unknown, thereby launching what is known as the world of fantasy.

Examples of the above-described function of the unconscious can be found in the production or creation of fantasy solutions for various

Epona, the Celtic goddess of creativity, riding a horse. The goddess herself was often personified as a white mare. Giraudon.

problematic human situations now described under the term *mythology*. Fantasy was thus invented not only to cope with the day-to-day problems of life but above all to aid in the search for the reasons for man's existence. To quote Dr. Jung:

A sense of a wider meaning to one's existence is what raises a man beyond mere getting and spending. If he lacks this sense he is lost and miserable. Only today do they think they can do without such ideas. If we do not know by reason of our need for salt in our food, we should nonetheless profit from its use. Why then should we deprive ourselves of views that would prove helpful in crises and would give meaning to our existence? Man positively needs general ideas and convictions that will give meaning to his life and enable him to find a place for himself in the universe. He can withstand the most incredible hardships when they make sense; he is crushed, when on top of all his misfortune, he has to admit that he is taking part in a tale told by an idiot. Myth is a primordial or primitive language. No intellectual formulation comes anywhere near the expressiveness and richness of mythical imagery.

The expressiveness and richness Dr. Jung refers to has been throughout the ages the hidden and often questioned source of artistic genius. Great artists of the past and present have often struck that incredibly rich vein of creative feeling from the unconscious and have learned to feel and acknowledge its presence. The artist creates a state of mind in which time and space are not in accord with his conscious thought processes, submitting himself totally to the inner feeling. Unable to explain this high state of creative flow, the artist lovingly refers to it as being "kissed by the Muses," itself an archetypal expression.

In the case of Harold Hitchcock, he can, through his spiritual belief in the Subud Brotherhood, communicate with his unconscious and escape into the world of peace and harmony he initially experienced as a child at Thundersley. His works are full of primordial images and symbols and are the unconscious outcome of his longing and search.

These symbols function as the means by which the archetypes express themselves, and their representation may take a myriad of forms. However, the same basic pattern or motif exists as it has for aeons of time (Plates 7, 12, 13 and 20). The universal hero myth, for example, has been present in a variety of conscious forms since antiquity.

Confrontations with archetypes in literary, verbal, or visual form frequently evoke a deep emotional response, a sense of wonder and mystery often accompanied by an inexplicable feeling of déjà-vu. This is typical of the work of Harold Hitchcock. He has retained his contact with nature and the profound emotional energy this connection supplies. The combination of the automatism of his technique and the source of inspiration in the primitive unconscious has created art of a highly symbolic quality.

In the paintings of Harold Hitchcock, this omnipresent need for hero identification expresses itself in the King Arthur Series (Plates 7, 12, 13 and 20). The progress of evolution brought man to the point where he could divert his instinctual energy into an analogue of the object of instinct. This analogue is what Dr. Jung means by a symbol. The symbol bears resemblance to the original, but is by no means identical with it. This propensity for man's unconscious to invent symbols has enabled him to evolve from being a creature of magic and superstition to being the man of science, technology, and art he is in the twentieth century. Symbols, being the archetypes' means of communication, reveal the ancient primitive yearning for completion, rebirth, harmony, purification, and wholeness.

Thus the symbolic images and myths surviving from the past have allowed mankind the rediscovery of his inheritance, and to quote Dr. Jung again: "The analogies between ancient myths and the stories that appear in the dreams of modern patients are neither trivial nor accidental. They exist because the unconscious mind of modern man preserves the symbol-making capacity that once found expression in the beliefs and rituals of the primitive."

Hitchcock's paintings, replete with symbolism, are a record of man's past history and are also unwittingly a personal psychological history of the artist's inner struggle to selfhood. Submitting himself to the emerging voice of the unconscious, the inner feeling, the artist allows the archetypes to speak out and reveal themselves. The unconscious and conscious have achieved a union, and only in this state is the artist, or for that matter any individual, able to fully realize his potential. This "transcendent state" or total submission to the forces within best describes Hitchcock while painting and is characterized by feelings of wholeness, joy, and inner harmony. His works are apparently an in-

tensely moving record of the transcendent state, brimming with peace and tranquility, and filled with endless mystery and numinosity. Add to this his technical brilliance as a draughtsman and colorist, and one realizes his truly unique form of expression.

The response to Hitchcock's work is in part deep admiration for the visual beauty of the light effects he achieves, coupled with a hypnotic attraction to his enchanted world of trees and water. Unbeknownst to him, messages of great wisdom from his unconscious are expressed in a fascinating variety of symbols in an attempt to impart solutions to age-old problems (Plates 7, 12, 17, 18, 20–22, 24, 26 and 31).

It is essential and salutory to discuss incomprehensible things. The current dominance of logic has resulted in the perfunctory dismissal of the mythic nature of man. To the intellect, fantasy is speculation. To the emotions, it is healing and vital, endowing existence with a glamour which it is futile to deny. Harold Hitchcock's work has the same healing effect on our emotions.

The artist tries to express what one might call a "participation mystique"—the feeling that humans are a minuscule part of a greater natural order. The theme of weightlessness in sculpture and flight in paintings is a recurring attempt to express freedom from our mere earthly existence in return for spiritual reality. Symbols are representations and projections of all aspects of man's psyche and the unification of these opposites leads to transcendence. Hitchcock's paintings are an expression of that unity, and Lucien Lévy-Bruhl has said that they "are a form of hypnotic language that takes us back to a lost paradise, to cosmic secrets, and teaches us to understand the language of the universe."

Symbols are used by man in an attempt to express concepts or ideas that are beyond the range of human comprehension. They appear in a multitude of forms, implying and hinting at occurrences vague and se-

cretive. Occasionally inanimate objects would appear to be in liaison with the unconscious, producing symbolic occurrences. Dr. Jung refers to the incident of Frederick the Great's clock stopping without any mechanical reason at the time of the owner's death. One may recall a similar incident occurring at the time of Harold Hitchcock's birth.

Symbols are external manifestations of the archetypes and modern man's conscious behavior patterns are to a high degree directed by them. Examples of this control of men's conscious behavior may be seen in a great variety of instances in everyday life. The connection between the birth of Christ and the decoration of the Christmas tree, the association of Easter with eggs and the rabbit are only the most apparent ones.* The elevation of ordinary mortals to national hero stature is yet another common phenomenon of this kind in modern times, providing a striking parallel to the ancient myths of the past. The universal pattern was humble birth; early proof of superhuman strength, wisdom, or ability; a rapid rise to power with an equally precipitous demise through the sin of pride (Plate 20).

Furthermore, on an individual basis a person's psychic development is determined by a process of self-fertilization from the unconscious and in the recurring motif of our behavior and dreams we attest to this fact. In people of artistic genius, the inner images not only mold their own personalities but are given universal application by virtue of the artists' poetic imagination.

*The parents of most children would be most embarrassed if they were asked to explain the connection between the birth of Christ and the evergreen tree decorated with lights; or the association of Easter and the resurrection with rabbits and painted eggs.

Although many of our number have no religious faith, we might express inwardly some sentiments at Christmas about the mythological birth of a semidivine child. Unwittingly we have succumbed to the symbolism of rebirth. The evergreen tree is connected with Christmas as a relic of an immensely older solstice festival which carries the expectation and yearning for renewal of the northern winter landscape.

Christ's birth, death, and ascension followed the pattern of the cyclic religions in which the death and rebirth of the God-King was an externally recurring myth relating to the mysteries of nature. The finality of the resurrection probably forced the early Christians into supplementing their beliefs with elements of the older pagan fertility ritual. The cyclic, recurring promise of rebirth was needed and that is what is symbolized by the eggs and rabbit at Easter and by the evergreen tree at Christmas. In all our sophistication we still find satisfaction in these symbolic festivals, intellectually oblivious to their meaning.

Plate 18: (above) **Thundersley,** *1978. 12½″ × 19″ The little boy, in a ritualistic pose of supplication, is offering flowers to a bear that looms menacingly from the forest. (Compare this painting with the illustration on page 74, top.) Standing behind him is a stag, a symbol of self-rejuvenation. This painting was done by the artist in an attempt to recreate his visionary experience described on pages 28 and 29. The motif is that of the ascendancy of man's spiritual nature over the lower instincts, the latter represented by the symbol of the bear.*

(left) Detail of Plate 18

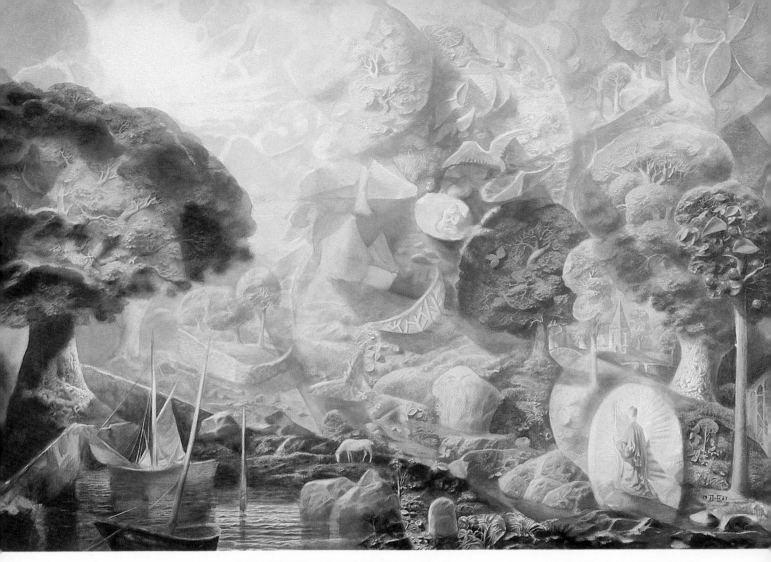

Plate 19: Road to Damascus, 1966. 30" × 41"

Plate 20: St. George, c. 1975. 29" × 43"

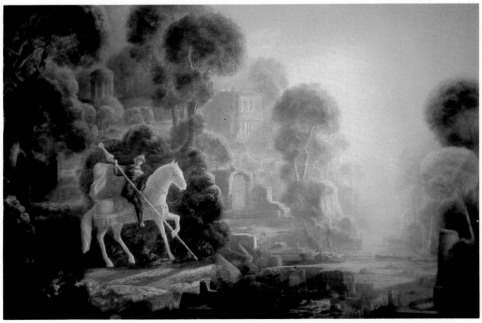

Plate 21: (below) **Dream Sequence,** *1977. 27″ × 29″ The ship in the right foreground is a frequent symbol of the church; a drawing found in the catacombs (page 102) depicts the same object. On the sail is a Maltese cross, the Christian symbol of salvation. The biblical couple may be a composite symbol of transcendence, and as such an echo of the hermaphrodite symbol on page 74 (top). The relaxed figure in the foreground holds a staff, symbol of authority, pointing to a tree which magically becomes a road leading into a wondrous landscape.*

Plate 22: (overleaf) **Riverside Farm,** *1975. 29″ × 43″ A couple stands in an animated forest in which a broken tree in the foreground has taken on the appearance of a prehistoric creature rearing up in agony. The face of a Spanish conquistador peers from the large tree on the right.*

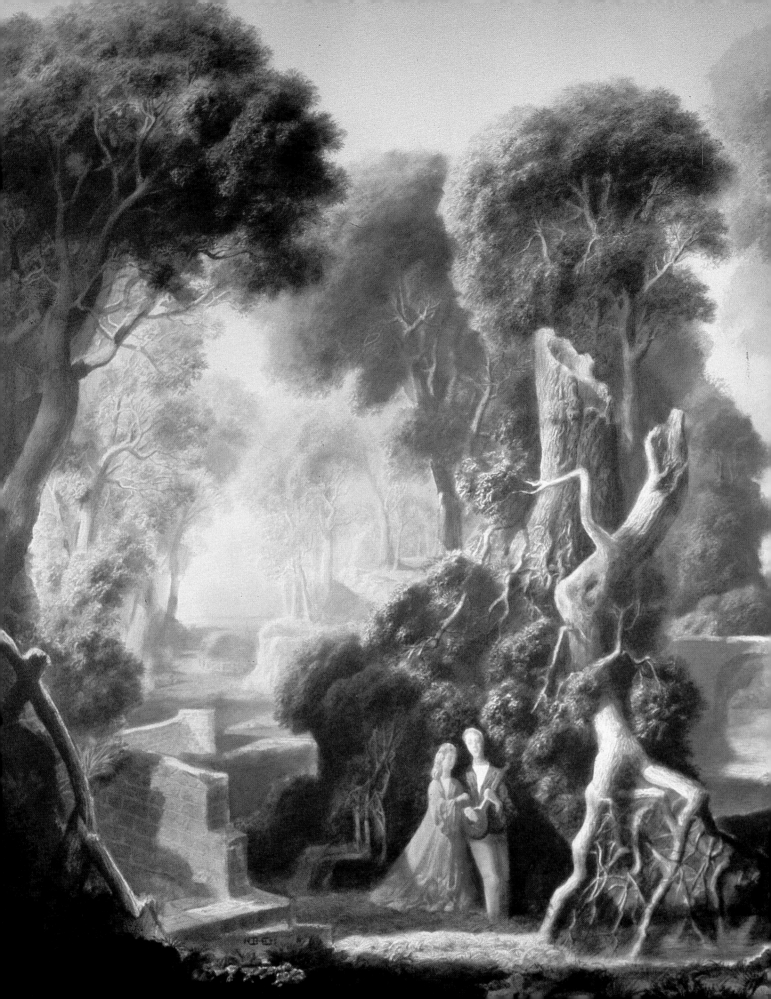

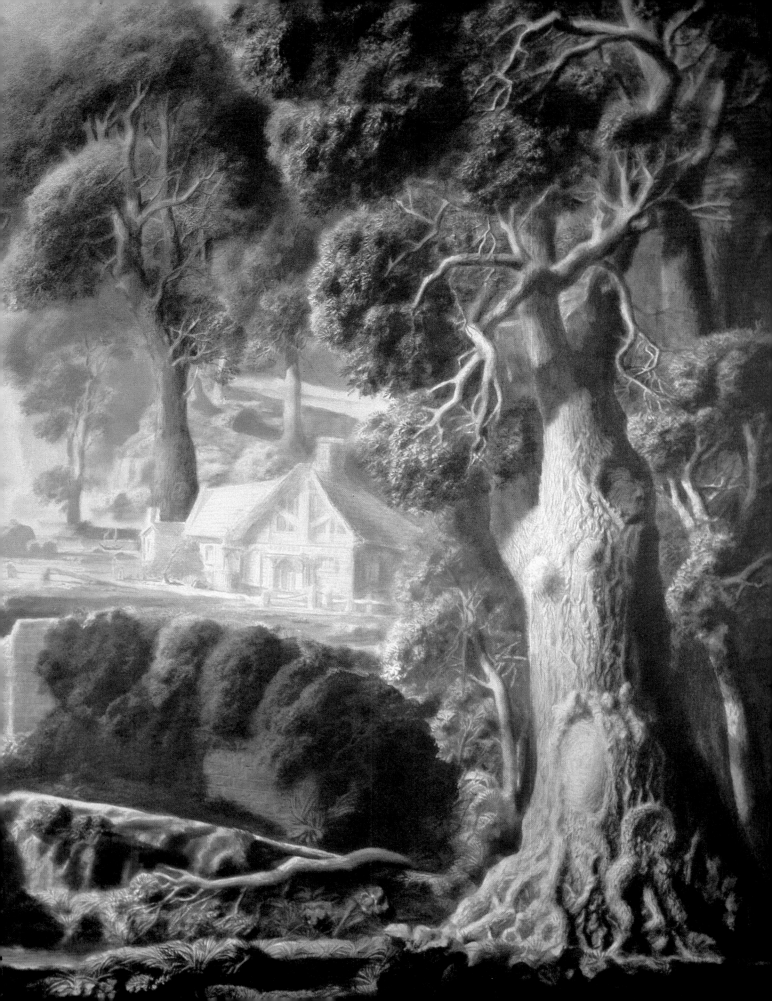

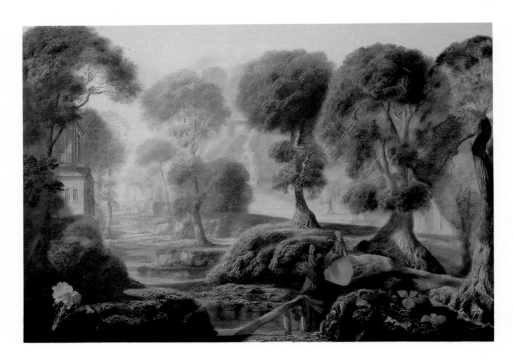

Plate 23: (right) Untitled, 1974. 20" × 30"

Plate 24: (below) **Entrance to the Temple of Jupiter,** 1976. 20" × 30" *The anchor in the left foreground is a symbol of hope and certain resurrection. Compare the symbols in this painting to the illustration on page 102.*

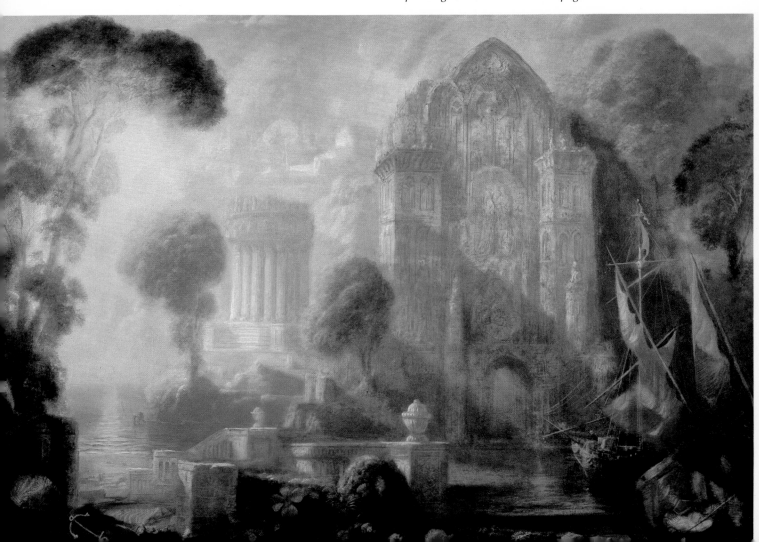

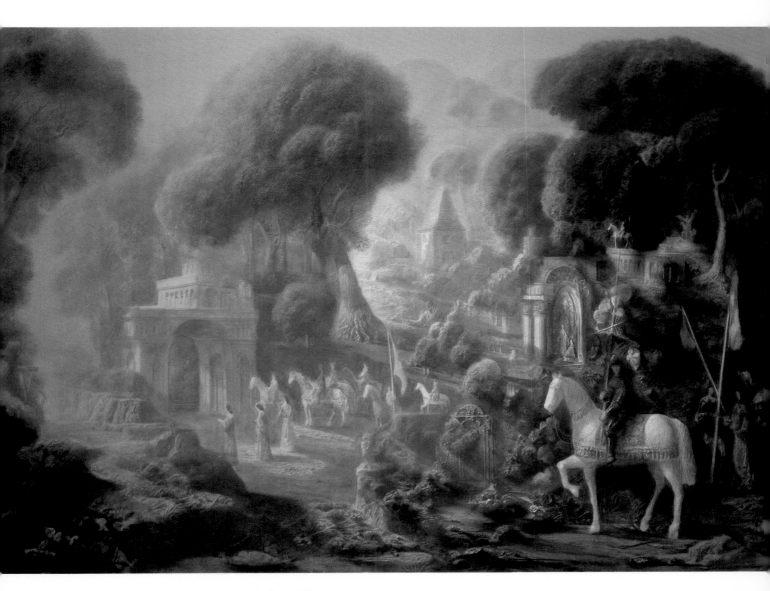

Plate 25: Ceremony at Sunset, *1977. 20″ × 30″*

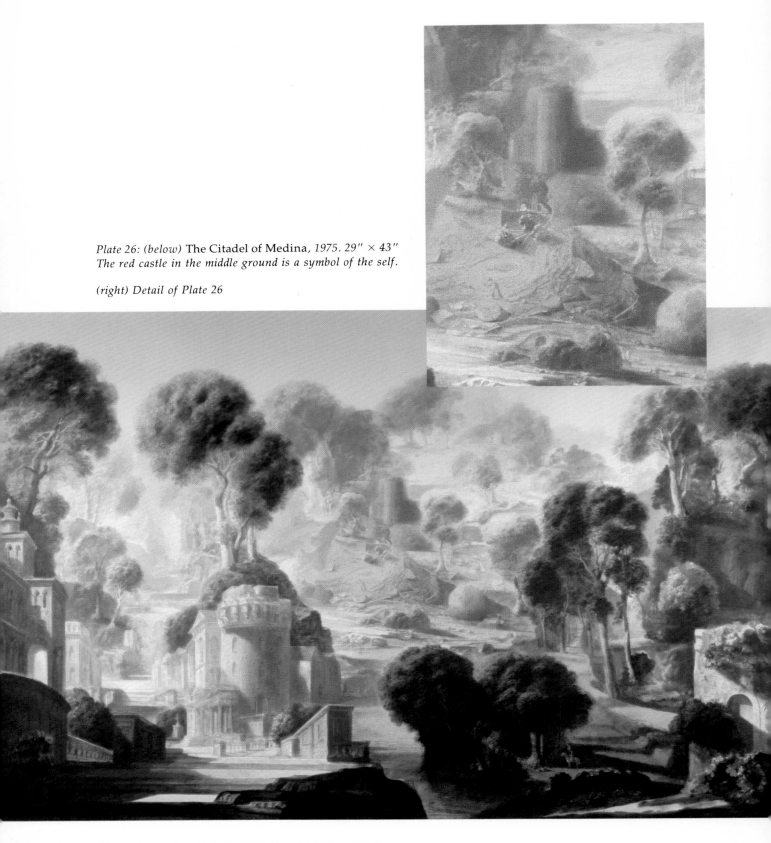

Plate 26: (below) **The Citadel of Medina**, *1975. 29" × 43"*
The red castle in the middle ground is a symbol of the self.

(right) Detail of Plate 26

Great art or literature draws its strength from the existing state of mankind and its meaning is completely missed if we try to derive it from personal factors. To quote Carl Jung, ''Whenever the collective unconscious becomes a living experience and is brought to bear upon the conscious outlook of an age, this event is a creative act which is of importance to everyone living in that age.''

Like an individual, an epoch has its bias, particular prejudices and limitation of conscious outlook, and requires a compensatory adjustment. This is effected by the collective unconscious of artists who give form to the unexpressed longings of their times—the unconscious Zeitgeist of the future. Great art is an innate drive that seizes an individual and makes him its instrument, transforming him into the higher universal man. We may witness this fact in the *Divine Comedy* and in *Faust*, where many identifiable and recurrent symbolic figures appear in the text. In performing this office it is frequently necessary for the artist to sacrifice the everyday activities of life, because he is overcome by a ruthless passion for creation. It was not Goethe who created Faust, but Faust who created Goethe.

Primordial images and symbols appear in the dreams of individuals and in works of art whenever the conscious attitude or general outlook is out of joint. They are activated instinctively when there is waywardness or a false attitude, restoring the equilibrium of the age. In this way the artist fulfills himself and the spiritual needs of the society in which he lives, creating art which is objective but nonetheless deeply moving.

Human instincts are of great antiquity and their form appears as an image in the minds of those who are receptive, expressing the nature of the instinctive impulse visually, like a picture. These are the primordial images anticipating changes to come, acting like catalysts to prod our cultural adaptation in a changing world. In the present mood of world destruction and nihilism, Harold Hitchcock's art is an example of this process at work, symbolizing the need for world renewal and a metamorphosis of our fundamental principles.

The Arts

Characterized by revolutionary break-throughs in modern science, notably the birth of psychology, the twentieth century has been described as the era in which man more than ever before discovers himself. The interpretations of these discoveries often manifest themselves in artistic expression, enabling people in the centuries to come, to analyze and reflect upon the culture of the time.

However, as scientific thought began to flourish, the philosophy of religious feeling, of the irrational, which hitherto had played so great a part in people's lives, was increasingly submerged in the triumph of logic. This psychic rift, first appearing in the Renaissance, and manifested by a conflict between knowledge and faith, seeks expression in modern art.

Confronted with the work of Harold Hitchcock one will readily agree that the artist stands solitary in a mixed world of trends, fashionable styles, and forced differences. His art is the reflection of some truth and beauty that lay hidden until brought to our attention, releasing a certain spontaneous delight in nature which ultimately is the sine qua non of the successful landscape.

In appealing directly to our emotions, Hitchcock falls naturally into the classification of Romanticism, which was a sweeping revolt against reason, science, and order. With Classicism, it has been established as one of the two major polarities of art. The major unifying force among its artists was a cultivation of individuality and, among other things, a means of expressing profound inner emotions.

Harold Hitchcock, a man of small stature and retiring manner, nonetheless is invested with a remarkable presence. An innocent of the spirit, with a profound sense of humility, he is contemptuous and deeply distrustful of the intellect as the sole means of solving modern man's dilemmas. Here is his philosophy on the state of the arts:

I feel that when you compare the last great outpouring of the creative impulse towards the end of the 19th century, and when one realizes what was given to us in the realm of literature, music, and the arts before the full impact of the Industrial Revolution, it is clear to me that man gained his inspiration from his natural environment. The power of nature provides the creative impulse; it does not reside in materialism. In nature there is a living vital force which animates and gives meaning to our existence. When one considers the number of giants of that period—

Beethoven, Brahms, Goethe, Schiller, and so on—men who produced immortal works that will enrich mankind for thousands of years, it was almost as though they sensed within themselves what was to come, the deadening effect that the spread of technology would have on the spirit of man.

Since the turn of the century, man felt his inspiration waning. Without knowing it he was grasping at anything he could get hold of in a pretext for doing something new in order to fill the empty vacuum within himself. Rather like the allegory of the fox and the grapes. Not knowing that this void was caused by the impact of the sordid type of society he was living in and engendered by the 20th century world of materialism. I feel that there has been a destruction of what I would term the cosmic vale that exists over nature. The supremacy of nature has been destroyed and replaced by the supremacy of man—a pitiful imposter.

We have seen in successive movements in music, literature, and the arts the restlessness that has occurred and the increasingly neurotic expression in the arts the more it becomes divorced from spiritual reality. It is significant that as each movement came into being it was ferociously defended by the intellectuals and the scientifically minded as being of major importance. Every lunatic [fringe] movement is so defended by those self-appointed arbitrators of public taste. We have been brainwashed on a massive scale and the public thinks that meaningless daubs of paint must be good because of the acceptance by the critics and intellectuals.

The function of an artist is not understood. We are given to understand that an art form is completely inanimate, exists in its own right and does not have to tell a moral or spiritual story; it is a decorative object that one can contemplate.

This is the complete opposite of the true function of the arts, whether literature or other art forms. The true function of all the arts is to guide man towards his true destiny, towards a true understanding of himself and his inner nature. As we progress on the evolutionary scale, so must we [proclaim] that state of spiritual realization we have grasped or comprehended through whatever medium we may choose, rather like a bridge to help other people. The artist must cut across the spirit of the age. It is not his function to reflect the conditions of the age; he does not want to be reminded of the depressing conditions without. His function is to follow

*the unmistakable voice within—the light that should be made known. The
external material world is the darkness of which we all are so painfully
aware. Increasingly, we see artists cajoled into reflecting that darkness.*

*For myself, I just follow the inner feelings, not allowing the intellect
to obstruct the creative impulse. This heightened feeling [of being some-
where else] to a large extent determines the outcome of my work.*

His worship of nature coupled with spiritual exploration is certainly
nothing new in the world of art. Not only does this remind us of the great
Claude and of Turner, but also of the German Romantic painters of the
early nineteenth century as well as works of Samuel Palmer (Plates 25
and 27), John Martin, and particularly William Blake (Plate 21). In his
distaste for the impact of modern technology on life, Hitchcock is merely
echoing the prophecies of his great English predecessor, William Blake,
who was perhaps even more opposed to the supposed dawning of an era
of enlightenment through science. With remarkable prescience he
foresaw in the coming age of human self-sufficiency "all the dreadful
potentialities of human arrogance and destructiveness whose fulfillment
we have witnessed in our time." The means by which Blake was able to
contemplate the mysteries of our times and reveal them to us through
poetry and painting was what he called the *Imagination.* Remaining
steadfast despite earthly burdens that would have deflected others, he
soon realized that life was a paradox of good and evil, and that this was the
material to make or break a man.

The following verse expresses Blake's comprehension of life's tur-
moil: (The illustration on page 74, top, expresses the same philosophy.)

Joy and woe are woven fine,
A clothing for the soul divine,
Under every grief and pine,
Runs a joy with silken twine.
It is right it should be so;
Man was made for joy and woe;
And when this we rightly know
Through the world we safely go.

As surely as these lines were written in eighteenth-century London
by Blake, so Hitchcock had to relive their bitter realities in twentieth-

(left) The young Arthur alone has the power to draw the magic sword from the stone. The story is a widely-known example of the hero myth. Bibliotèque Nationale, Paris.

(below) The necessity for heroes still exists in our modern society. Like a conquering Greek or Roman warrior, Astronaut John Glenn is welcomed to the nation's capital with a parade after his orbit of earth. United States Information Service.

century London of the 1940's and 1950's. In a hospital ward, two days prior to a major operation for relief of the cursed pain of trigeminal neuralgia, Hitchcock wrote the following lines:

We the heroes of life, undaunting into the realm of tumultuous care, grinding inexorably in the dust of time, the cherished illusions born of man's conceit.

Men of science, of learning, of intellect born of reason. Witness the darkness heralding the storm and the machinery of destruction crowning all.

But we, who have retained the vision of celestial forests in this fair realm must close our ranks and carry high the banner of universal brotherhood and freedom and in the service of our creator, bring light into a darkened world.

Hitchcock's paintings echo the ideas in Blake's poem. They are similar philosophical statements on life itself, contemplations on existence, but in a visual, rather than verbal, form. The medium of landscape painting has provided artists with an admirable outlet for such convictions through the centuries. By combining his current beliefs and emotional response to nature, Hitchcock is inspired to create an imagery derived from the collective unconscious. Conveyed in this imagery is a sense of great spiritual awareness of a higher order. These unique mythological inventions continue the tradition of witnessing nature as a reflection of divine purpose.

In seeking an explanation for the atypical quality of Hitchcock's work it is intriguing to compare social circumstances prevailing in the sixteenth and twentieth centuries. Both can be characterized as times of great violence and uncertainty, of continual war between rival ideologies, and of diminished confidence in reality. At the time of the Reformation, Bruegel the Elder reverted to a pre-Renaissance format and that is what Hitchcock does in his time. As did the Pre-Raphaelites, so he cuts across the spirit of the age, reasserting values no longer acceptable or fashionable. His mythological landscapes contain a body of constructive moral principles that are conveyed to the viewer by means of allegory and symbolism. His atmospheric evocations are attained independently, through the subtle use of color and form.

The Light of Understanding

His function is to follow the unmistakable voice within—the light that should be made known. H. HITCHCOCK

The artist's paintings will be remembered as a symbol of that which was lacking in the times he lived. The incantations of Marxism and socialism have certainly been a failure at the moral and intellectual level, leaving us with nothing but materialism, and that, a relative vacuum, is insufficiently edifying for the human soul. Perhaps through an appreciation of nature, belief in divine powers might again be an appealing thought to modern man living in his concrete jungle.

Hitchcock's involvement with nature became a sort of mystical experience at Thundersley. It was by no means unique. Jean-Jacques Rousseau, the French philosopher, revolutionized thought in the eighteenth century after a similar experience at the Lake of Bienne in Switzerland. While listening to the lapping of waves on the shoreline, he felt and became completely at one with nature, and propounded the theory "I feel, therefore I am"—a conclusion independently achieved by the Scottish philosopher Hume by logical means.

When Monet and Renoir met at a riverside café, La Grenouillière, in 1869, they were painting in the traditional style of the landscape artist. Little did they know that their experience of witnessing the effects of light on water that day would be a momentous one in the history of art. The pursuit of the immediate sensation of light as the dominant factor in a painting was unwittingly a conclusion similar to the philosophic theories of Hume and Rousseau. So also was Hitchcock's enraptured vision at Thundersley when he saw the jewel-like sparkle of light on the elm trees. He is able to memorize even the most fleeting effects of light and, like Turner and Monet, has used his optical sensations to guide him to the truth (Plate 14). His light keeps the eye occupied to the point of obsession in a most uncanny way but the atmospheric mood conveyed is entirely different from that of the Impressionists, precisely because the feeling generated by this formative moment was different. It is one of serenity and silence, as in a church cloister. His work is based on instinct, not learning, and is an extension of the immediate feeling. His representation of nature is a purely inspirational one, like the great English Romantic poets. He approaches Coleridge more than any other

THE LIGHT OF UNDERSTANDING · 95

The Maltese cross, a Christian symbol of salvation.

because of his highly mystical style, and the poet could have been describing Hitchcock when he wrote: "He looked at his own soul with a telescope. What seemed all irregular, he saw and showed to be beautiful constellations; and he added to the consciousness hidden worlds within worlds."

His use of light is more than an observation of its natural effects; it has a hazy mystical quality, symbolizing those "hidden worlds within worlds." It is the most noticeable and dominant element in his work. It bathes, envelops, and intrigues. It is a cohesive factor. It tantalizes the eye and visually pleases. One could rhapsodize on the technical aspect of light in Hitchcock's work with considerable justification. I would prefer, however, to pursue a different course for a moment to clarify the symbolic aspect of his light. We must journey back to Africa and reconstruct how light has indeed been associated with the world beyond reason.

Modern visitors to the regions of equatorial Africa are noticeably impressed by the intense and moving sunrises, and well they should be. For here in all probability ancient man had a similar experience and formulated from it his primitive religion and faith. It was an intuitive realization. To this day a tribe called the Elgonyi worship the moment of sunrise *(Adhista)* as their God—it is the most dominant force in their lives. They worship by spitting or breathing on their hands and turning them skyward to the sun. This act symbolizes the giving of their spirit of life to their God. The are quite unaware of the meaning of the act, as are many modern people in the performance of their own litanies.

From time immemorial man has worshipped the sun and its life-giving light as a great god who saves him from the terrifying darkness. The recognition of light as a possible first act of consciousness was also perhaps the first acknowledgment of the human soul. It symbolizes man's highest achievement—the beginning of his cultural evolution, that which distinguishes him from all other creatures.

"Let there be light" was the imperative from the Book of Genesis, "and life grew and spread upon earth." The same worship of the sun as a divinity can be found as one traces the course of the Nile to the Mediterranean and thence to Western civilization. The principle of light is identifiable in Horus, the Egyptian Sun God, who later became represented as a winged sun disc. The Greeks continued to use light as a symbol of expression of their highest ideals. Initially Phoebus, then later Apollo,

An ancient Christian drawing found in the catacombs, depicting the anchor as a symbol of hope and certain resurrection. The fish is a symbol of Christ. Aldus Books, Ltd. © 1964, London.

became associated with the sun. He was the embodiment of the classical Greek spirit and was essentially concerned with healing and prophecy; the arrows from his bow were compared to the rays of the sun by Renaissance mythographers. And so to the modern world, where the advent of Christ was heralded by a star, and every year countless candles are lit in churches and placed on Christmas trees in the remembrance and hope that the teachings of Jesus will be brought into the supplicant's life. It is always the same divine light or revelation that is sought, the question of man's relationship to something infinite.

"You shall be a light unto others," prophesied the English mystic; and even now spiritual life grows and spreads among those touched by Hitchcock's art.

In Hitchcock's case, the ecstasy he experienced as a child at Thundersley was akin to the feeling of being in the Garden of Eden once more. His unifying light is an expression of love for all things in nature and is conceived in humility imparting a sense "that the moment is blessed and eternal," as in a van Eyck painting. A man of great profundity, his work is the testimony of one human spirit.

Harold Hitchcock's paintings are an expression and an outcome of his concept of life. The general feeling of joy and wonder conveyed in them strikes a responsive chord in all of us. It is bounty reaped from that philosophy. Malcolm Muggeridge, the eminent English writer,

describes with inspired clarity the rationale for Hitchcock's joy and wonder:

> *The efforts that men make to bring about their own happiness, their own self-indulgence, will in due course produce the opposite, leading me to the absolutely inescapable conclusion that human beings cannot live and operate in this world without some concept of a being greater than themselves, and of a purpose which transcends their own egotistic or greedy desires. Once you eliminate the notion of a God, a creator, once you eliminate the notion that the creator has a purpose for us, and that life consists in essentially fulfilling that purpose, then you are bound, as Pascal points out, to induce the megalomania of which we have seen so many manifestations in our time.*
>
> *But if you should know that you are as an infinitesimal particle of God's creation and purpose, then with this certainty comes an extraordinary sense of joy and wonder. The essential feature and necessity of life is to know reality, which means knowing God. Otherwise our mortal existence is no more than a night in a second class hotel.*

We are not required to experience life like a night in a second-class hotel, or as Thoreau says, in "quiet desperation." By living in communion with nature and ourselves we can celebrate life's beauty and mystical overtones.

A drawing in the catacombs. The ship symbolizes the church, the bird, transcendence. Aldus Books, Ltd., © 1964, London.

Landscape and Hitchcock

Il est essentiellement peintre d'aquarelles exécutés dans un style fortement influencé par Claude Gellée, Turner et les Pre-Raphaelites. Ses thêmes, rendue avec precision, sont des passages imaginaires, des marines sous des effects de soleil. BÉNÉZIT

Bénézit, in its reference to Harold Hitchcock, describes his work as being reminiscent of the works of Claude Lorrain (Plates 6 and 11) and Joseph Mallord William Turner. The reason for this statement is quite obvious. While the highly imaginary setting and sensitive depiction of light does indeed remind us of the works of Claude, Hitchcock's ability to portray the inner spirit of nature's phenomena gives his paintings their incomparable Turneresque quality (Plate 14).

Hitchcock continues to confess the presence of a supreme being whose existence is revealed in one of many ways by the living vital forces in nature. His works appear to be orientated to awaken this sensibility within us.

Thus, here are two books whence I collect my divinity, besides that written one of God, another of his servant nature, that universal and public manuscript that lies expansed unto the eyes of all. Those that never saw him in the one have discovered him in the other.

RELIGIO MEDICI

In the artistically highly productive age of the nineteenth century one art critic stood out among the many. Using a radically new concept of art evaluation he was the first to recognize and accept a new highly controversial school of art. His name was John Ruskin, "the apostle of beauty" as he was called by his contemporaries. The beauty he so strongly pleaded for was never sensuous or pagan, but spiritual, appealing to the soul of man rather than to his eyes, leading not only to better work but also to better living.

Ruskin proposed that the world has had essentially a trinity of ages; classical, medieval, and modern. Classicism started wherever civilization began with pagan faith. Medievalism originated and continues wherever civilization confesses a supreme being. The denial of this supreme being, however, characterizes the age of modernism. The opinion of John Ruskin expressed in general terms is that art is only

then pure and more noble if it is dedicated to some spiritual reality. If it is not in the service of some greater truth, it will never survive.

John Ruskin's opinions were shared by a group of rebellious young artists who in the mid-nineteenth century strongly reacted against the art establishment of the Royal Academy. They adopted a name, the Pre-Raphaelites, and formed a brotherhood in 1848 based on their belief that the principles by which art had been taught for the past 300 years were essentially wrong and that one should revert to the times preceding Raphael. The group immediately began to create significant works celebrating the values and quality of life in the past. Their paintings met with great criticism among the art establishment and only because of a strong article in their favor by John Ruskin in *The Times* did they receive recognition.

For many decades considered most unfashionable, the Pre-Raphaelite Brotherhood has only recently been recognized as one of the most significant schools of art and thought of the nineteenth century.

Again it becomes quite apparent when viewing the works of Harold Hitchcock why *Bénézit* compares the artist to this school (Plate 32 and detail of Plate 1). Like the earlier artists, Harold Hitchcock was disillusioned by the expressions and trends of modern art. It is his conviction that art must serve some higher purpose, and just like the Pre-Raphaelites, he finds his artistic companions to be the painters of the days before Raphael.

Ruskin was totally committed to naturalism and this led him to severely criticize the work of Claude in his book *Modern Painters,* primarily in those areas in which he expands on his concept of the pathetic fallacy. However, Kenneth Clark, in *Landscape into Art,* presents a more balanced and dispassionate view of the landscape. He submits that through the ages man has attempted to convert the complexity of natural appearances into the unity of an idea, each bearing relevance to the social and historical events of the age. He suggests that the several ways by which we might view landscape as a means of pictorial expression are: the landscape of symbols; the landscape of fact; the landscape of fantasy; the ideal landscape; the twentieth-century landscape.

Landscape of Symbols

IT IS DIFFICULT for people in the twentieth century who have been exposed to the glorious landscapes of the nineteenth to realize the genre's com-

paratively short history. Hellenistic and Roman culture had been so immersed in human values that nature was subordinated, and landscape painting awaited the Middle Ages before its development signified an attempt by the human spirit to harmonize itself with the environment. In medieval times there was a mistrust of nature and thus it was portrayed with feelings of hostility and in a symbolic manner in accordance with the unconscious bent of the human mind at that time.

Gradually natural objects became appreciated in their own right, but they were also seen to be of divine significance. The menacing environment of the Middle Ages was replaced by a more peaceful world where God walked abroad and this concept was fueled by the writings of Dante and the poets of the early fourteenth century. The delight in this form of landscape involved the evocation of pleasing decorative patterns within a garden setting. Plate 34 illustrates Hitchcock's painting of this type. The move toward another form of landscape was occasioned by a new concept of space and light.

ONE COMMON THREAD that unites the masters of landscape is their use and feel for light. According to Kenneth Clark, "facts become art through love, which unifies them and lifts them to a higher plane of reality; and in landscape, this all embracing love is expressed by light." The first paintings that can be considered to fall under this category are those from the Netherlands in the fifteenth century, where a dogged pursuit of truth was pre-eminent. The Flemish mastery of light as seen in the work of the van Eycks was superior to that of their Italian contemporaries, and their achievements were not noticed and enhanced until the period of the Venetian master Giovanni Bellini, whose landscapes were conceived in a mood of profound humility. There is a unity of atmospheric expression which is the outcome of both Bellini's emotional response to light and his universal love for all things in nature. After Bellini, the factual landscape did not reappear until the seventeenth century in Holland, when that bourgeois society demanded unidealized views of the country it had wrested from the Spanish. Additional factors in the reappearance of this kind of painting were the exhaustion of the tradition of mannerist landscape and a resurgence of scientific interest in light, exemplified in the discoveries of Leeuwenhoek and Newton. The Dutch augmented the use of light by altering its character from static and

Landscape of Fact

saturating to one of continuous movement, primarily through the medium of the vast skies that occupy two thirds of their land- and seascapes.

Shortly thereafter, when the rendition of light ceased to be an act of love but became dependent on mere technical facility, this form of landscape degenerated into topography. We must now return to an earlier century to consider another aspect of nature which gave form to the landscape of fantasy.

Landscape of Fantasy

IN THE FIFTEENTH CENTURY there was a body of artists who resided in the relative affluence of an urban environment and for whom the dread of nature had lost its sting. They exerted a measure of control over the forces of nature and so viewed their surroundings with a certain objectivity. Landscape had become too tame and so they sought to depict the wild and numinous side of nature which best represented the equivalency of the "shadow" in the human spirit. Their art is essentially expressionistic, a northern anticlassical form which is "forest born" and perpetuates in its imagery the art of the nomadic period. Trees dominate all and are so represented as to make the most instantaneous assault upon our emotions. Plates 22 and 28 exemplify this class of landscape. Grünewald and Altdorfer produced works of this type and it is apparent from studying their pictures that they were deeply influenced by the mystical writings of the time. The underbrush and trees are animated in such a manner that they appear to menace any person who dares intrude. Hieronymous Bosch also falls into this category and many of his works are among the most terrifying ever produced by the human imagination.

The next landscape form we shall consider is entirely opposite in mood and the product of an earlier vision of man.

The Ideal Landscape

IN THE SEVENTEENTH CENTURY it became the ambition of some to create imaginary landscapes which would match in content and design "those higher kinds of painting which illustrate a theme, religious, historical, or poetic" (Lord Clark) (Plates 5, 10, 16, 23, 25 and 27). Their inspiration was provided by Virgil, who wrote of the myth of a Golden

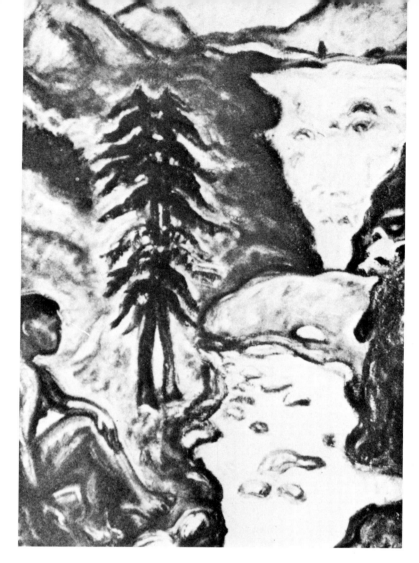

(left) A "soul," or fantasy landscape by the modern artist, Slavko. As in Hitchcock's paintings, there are many unconscious symbols. A bear appears here; a universal symbol of man's animal nature.

The Persian sun god Mithras sacrificing a bull. This symbolizes the triumph of man's spiritual nature over his uncontrollable instinctive forces, of which the bull or bear is a common symbol. Alinari/Editorial Photocolor Archives.

Age in which man "lived on the fruits of the earth peacefully, piously, and with primitive simplicity." This pastoral vision augmented by the Arcadian school of Italian poetry gave rise to the lyric landscapes of Giorgione and Claude and hearkens back to an even earlier time in the Garden of Eden. See the illustration on page 41. The persistence and reappearance of this vision would appear to substantiate Kenneth Clark's contention that it has proven to be an unequaled source of joy and consolation to mankind over the centuries. The poetic beauty of Claude's work, in which all is subordinated to one mood through the use of light, stands in contrast to his great contemporary, Nicolas Poussin, whose rationalism brought intellectual order to romantic subjects by means of classical design. In England William Blake and his disciple Samuel Palmer continued the tradition of the ideal landscape and gave to it spiritual and symbolic qualities that are reminiscent of the landscape of the Middle Ages. One feels in Palmer's work a sense of pastoral simplicity according to God's design, that by partaking of this rustic life man is ennobled.

Plate 27: (above) A Tidal Road, *1978.*
29¼″ × 43″

(left) Detail of Plate 27

Plate 28: A Forest Path, *1976. 30″ × 40″*

Plate 29: Untitled

Plate 30: The Unfurling of the Sails, *1978.*

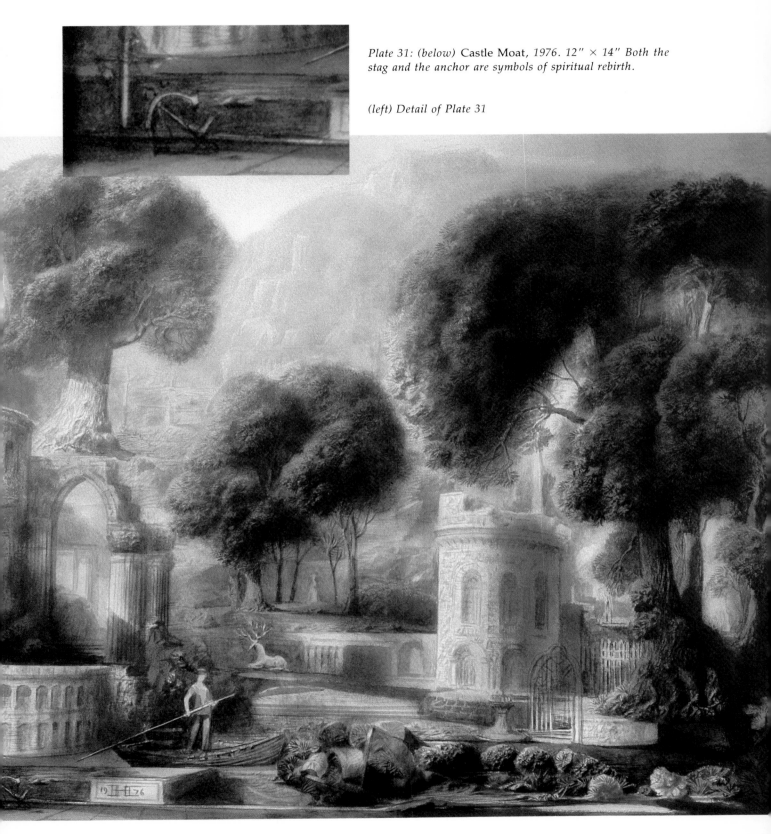

Plate 31: (below) Castle Moat, 1976. *12" × 14" Both the stag and the anchor are symbols of spiritual rebirth.*

(left) Detail of Plate 31

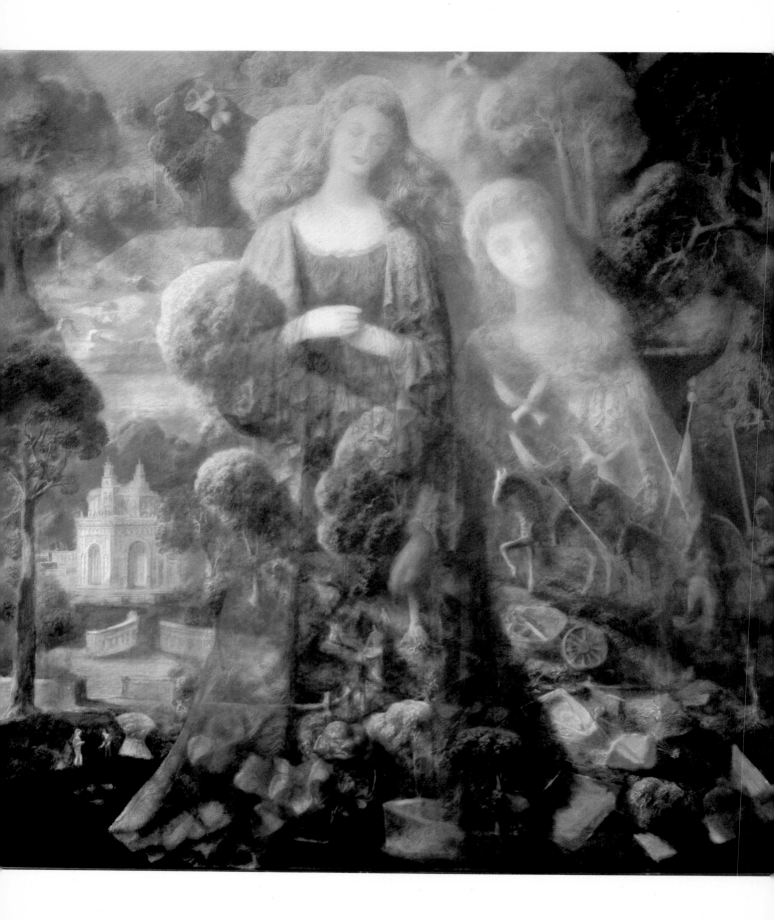

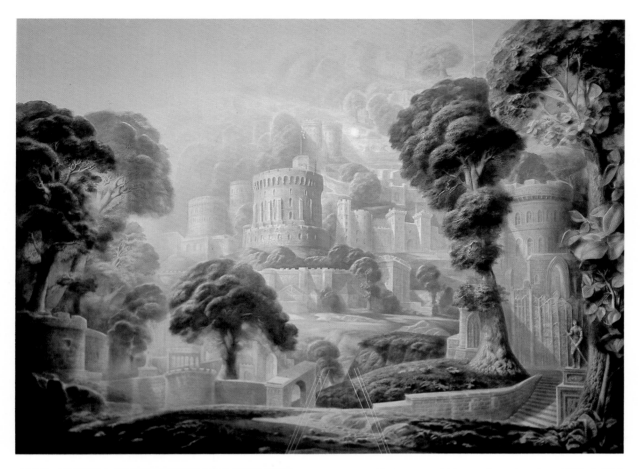

Plate 32: (facing page) **Protective Angels,** *1977. 29⅓″ × 30¾″*

Plate 33: (above) **Windsor Castle,** *1966. 38″ × 49″*

(left) Detail of Plate 33

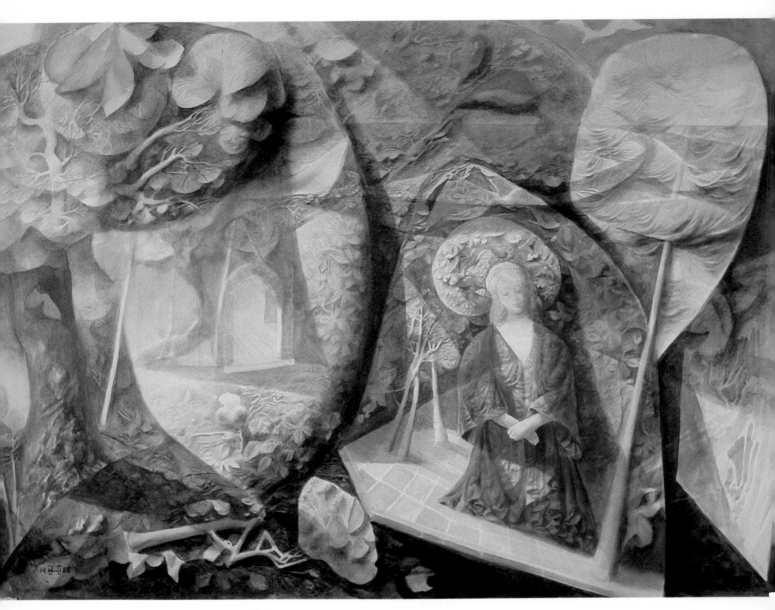

Plate 34: Madonna, *1965. 21½″ × 30″*

JUST AS THE IDEAL LANDSCAPE was an outcome of Virgilian concepts, so the nineteenth-century landscape was influenced by the philosophy of Wordsworth's nature poetry which was content to let natural objects speak their own message. And in John Constable, the poet found a kindred spirit whose work elevated naturalism through a belief in divine revelation, be it in flower, meadow, or mountain stream. By means of light and shade Constable achieved a feeling of unity in his paintings through subordination of the overwhelming wealth of detail in nature to a single pictorial idea. Both artists rejected eighteenth-century philosophy that the world was essentially mechanistic and sought to reaffirm Thomas Traherne's lines that "you can never enjoy the world aright, till the sea itself floweth in your veins, till you are clothed with the heavens and crowned with stars and perceived yourself to be the sole heir of the whole world." Great compositions were welded from observed facts and by the middle of the century an unchallenged belief in the natural vision was the basis of the landscape's becoming the preeminent art form. This is the concept that unites Constable, Corot, Courbet, Daubigny, and Pissarro, and in John Ruskin's text, *Modern Painters*, they found a champion who stated with eloquence that nature was indeed sacred and furnished a purifying and uplifting quality to those who viewed it without prejudice.

Being somewhat blinkered in his commitment to naturalism, Ruskin went on to coin the term "pathetic fallacy" to describe the poetic practice of attributing human emotion or responses to objects in nature. This personification, he allowed, produced a "falseness in all our impressions of external things." He would be sorely pressed in defense of his position when contemplating the work of two giants of nineteenth-century landscape, Turner and Van Gogh, whose work took on another form. They are, in modern terminology, expressionist painters, and in their landscapes of heightened emotion they achieved dramatic light effects that link them to the sixteenth-century landscape of fantasy. These effects could not have been portrayed by a factual approach alone and thus it is not surprising that in the paintings of Turner, a master of imaginative landscape, we find the advances that ultimately led to Impressionism. His use of color was of seminal importance in liberating art from the idealistic philosophy that form was a product of the intellect and color that of the senses. He orchestrated symbolic color equivalents

into form and produced designs from light and color alone.

It seems entirely appropriate that the latter half of the nineteenth century, an era replete with a sense of unity and confidence, should have given birth to Impressionism. The liberation of color from a purely decorative function and the concomitant rise in tone, so that we might see color even in shadow, enlarged our perception of the world at large and gave delight by unmasking hidden beauty. However appealing the immediacy of sensation may have been, it could not stem the tide of scientific knowledge which quickly followed and which sundered the concept of a unified world. The light and atmospheric effects that had come to symbolize that mystical notion retreated as the atomic era and its awesome forces of destruction proceeded apace. So man entered the twentieth century with a complete loss of confidence in his environment and proceeded to divest himself of any graven images. This trend away from the imitation of nature, if carried to its logical conclusion, would mean a death sentence for the art of landscape. I do not believe this will be the case, but I would like to detain the reader further in an examination of some dynamic aspects of twentieth-century thought which might conceivably influence the landscape of the present and future.

An earth altar in an Oriental painting. Such structures symbolize the self, to which the ego must submit in order for psychic growth to occur. The earth altar as a symbol appears in several of Hitchcock's paintings. For one example, see Plate 1. Crown Copyright, Victoria and Albert Museum.

IN THE ARTS the trend toward purism and the new concept of what is beautiful was the outcome of forces within science. It ran completely afoul of the traditional belief of "the beautiful" as seen in the landscape of the nineteenth century, when faith in nature was the religion of the day. While indubitably the vast majority of people are alienated from the new aesthetic, it would be myopic to deny the vitality of its contribution, and foolish to believe that the landscape of the present can exist independent of that mainstream. The drift to simplification has been accelerated by telecommunication and by photography especially. In books and museums centuries of creative works are so compressed in time and space that the artist can delight in the best from all styles and periods. He has expanded his aesthetic experience beyond that of nature alone, and instead of aiming for consistency of style as his prime objective, has sought to distill from each style that emotional assault called pleasure or delight. Once this aesthetic taste is developed it naturally turns towards the art of primitive people and to the medieval period (Plates 1, 12, 21 and 34). So we see in Gauguin the first attempt to achieve a pure aesthetic response. By an act of will he cajoled himself into seeing symbolically and recreated the landscape of symbols. By arrangement of color and line he obtained harmonies capable of stimulating thought in a manner similar to that of music.

Henri Rousseau, a true innocent of the spirit, ended at the same terminus as Gauguin by producing symbolic landscapes quite unconsciously, but intuitively he knew himself to be as modern as his contemporary, Picasso. His outrageous jungle scenes combine an expressive decorative pattern with the direct simplicity of primitive life in work that was no less shocking than the statements of his contemporaries in other fields. Cézanne also reduced the landscape to simplified forms in accordance with his visual sensations and not to fulfill any popular theory, as is commonly believed. The famous sentence from one of his letters used to support the theory of Cubism does not come off quite as well when quoted in its entirety. *"Tout dans la nature se modèle selon la sphère, le cône et le cylindre. Il faut s'apprendre à peindre sur ces figures simples, on pourra ensuite faire tout ce qu'on voudra."* It means that to master the representation of nature one has to do so in simple forms which as Kenneth Clark says, "provide an exercise in continuous modeling, and so are the contrary of Cubism." And although Cubism proved

to be an admirable vehicle for the depiction of figure compositions and still life, it, together with other forms of abstract art, is singularly unsuitable for the portrayal of landscapes.

Leaving aside those inclinations within art itself, we can identify in the field of science certain trends which were to act in concert with the above and be of catalytic importance in furthering the new aesthetic creed. First, the resurgence of the Neoplatonic philosophy that the eternally beautiful is that which can be stated in geometric or analytic terms fitted the needs of science, which as the dominating intellectual activity of the era in turn influenced art. A second trend is the destruction of the invincible belief in the unity of nature through the unveiling of a microscopic and even subatomic world whose awesome forces of destruction we now have at our command. The intimacy and love with which we viewed the old anthropocentric nature was replaced by fears similar to those that inspired the landscape of fantasy of the fifteenth century. In Grünewald's paintings and Leonardo's drawings the general fear was that nature was not harmonious, and science seems to have corroborated that fact. Therefore in these times of turmoil and violence in which we have lost all confidence in the natural order, expressionistic art may be the only means by which the individual human soul can vent its innermost experiences.

Kenneth Clark asserts that since landscape painting is at the furthermost remove from Platonic geometry and Cubist theory, it can surely exist as something complementary to the art of slide and rule, and that this is something we should crave all the more hungrily because of its exclusion from the Platonic approach. And furthermore, says Clark, the future of landscape painting resides in a reapplication of the pathetic fallacy.

The value of the expressionistic style in this unprecedented period of social demolition should not be underestimated. In his art and in his personal life Hitchcock represents an example of the free artist and exemplifies the essence of the importance of the individual in society. Out of a sense of real hunger he has recreated a series of landscape paintings which vary in style from the medieval landscape of symbols, to the ideal landscape of Claude, to the landscape of fantasy, and even to those of Turner. And he has not done so by borrowing from the past but by unconsciously creating new forms which are of significant social

importance. The continual process of self-discovery is essentially what is symbolized by Hitchcock's trees, and their roots are the inner source of strength and the raw material needed to fuel the process. In these days of imposed conformity and mechanization his work should be a model for those who despair. For we must all strive to discover our own individuality and express it despite ridicule. Only then can we give substance and meaning to life as we live it, and experience the feelings of self-worth and dignity that elevate a person above an existence of mere getting and spending. Hitchcock continues to take a massive gamble on his belief in himself and from that process has a sense of having made his own personal contribution that enriches himself and his fellow man. Expressed in another way by Andrei Sakharov, Nobel Peace Prize winner:

There is a need to create ideals even when you cannot see any route by which to achieve them, because if there are no ideals then there can be no hope, and then one would be completely in the dark in a hopeless blind alley. . . . Therefore, if a man does not keep silent it does not mean that he hopes necessarily to achieve something. He may hope for nothing but nonetheless speak because he cannot, simply cannot remain silent.

At a time when most artists have turned their backs on nature, for purposes of discussion I have initially chosen to classify Hitchcock as a twentieth-century surrealist fulfilling the prophecies of André Breton and the psychoanalytic theories of Carl Jung. In essence, however, he is a landscape artist of great distinction. His imagination has distilled, from light and color, poetry that recreates the medieval landscape of symbols and the ideal landscapes of Claude. He is a solitary and lonely figure in the world of twentieth-century art, but has not that been the lot of so many of our beloved ones?

GLOSSARY

Ankh Ancient Egyptian symbol denoting eternal life.

Anchor Early Christian symbol for the cross; now has come to mean steadfastness, hope and the certain resurrection.

Animal Animals or the animal motif symbolize man's instinctual or primitive nature. Man has a lower animal or instinctual nature, which he can no more dispense with than his higher spiritual nature.

Anima and Animus Personification of the feminine nature of a man's unconscious and the masculine nature of a woman's. This inner duality is often symbolized by a hermaphroditic figure as in the seventeenth-century alchemical manuscript in the text. It manifests itself in dreams and fantasies as a "dream girl" or "dream lover."

Archetype Literally an original model or prototype after which similar things are patterned. The archetype of "primordial image" is a tendency to form certain motifs. The myths and legends of world literature contain motifs which recurrently are encountered in the dreams and fantasies of modern man. They express themselves consciously as visual images, feelings or in patterns of behavior and are the human equivalent of instincts in animals. They originate in the collective unconscious.

Bird Symbol of spiritual transcendence because of its magical ability to fly. In general terms like the dove it represents the soul.

Cross Universal emblem for Christ representing salvation and having many variations. The T or Tau cross was anticipatory and a variation of the Egyptian Ankh. The Celtic Cross of Iona and the Maltese cross appear frequently in Hitchcock's work as variants.

Dragon The dragon slain appears in countless legends all pointing to the fatal presence of some evil principle and the ultimate triumph of good.

Earth Altar Such round or square structures usually symbolize the self to which the ego must submit to fulfill the process of individualization.

Fish The oldest Christian symbol of Christ from the Greek initials of "Jesus Christ, God's son, Savior" which spell out *Icthias* in Greek, meaning fish.

Individuation	Denotes the process of psychological growth by which a person realizes his own self or uniqueness, and thus becomes whole. Mandalas "frequently express the yearnings for such a goal."
Horse	Emblem of life. Epona, Celtic goddess of creativity, was often personified as a white mare.
Nimbus	Symbol of holiness and power.
Mandala	A Hindu word meaning magic circle. It represents enlightenment and human perfection achieved through realization of the center, the self or the goal. It has appeared in primitive sun worship, in rose windows of Christian churches and in Tibetan manuscripts.
Numinosum	A term for the inexpressible and mysterious. It pertains only to the Divinity.
Sail	Ancient Egyptian symbol for breath which quickens the inert, sends useless sail into service. The breath, like spittle, was considered symbolic of soul or life force which energizes the body.
Ship	The world is a sea in which the church, like a ship, rides in safety amidst the storms of life. The mast is generally in the form of a cross surmounted by a sail.
Serpent	This creature has a dual meaning. Traditionally as a creature of the underworld, it was a "mediator" between one way of life and another and symbolized evil or temptation. It was also a symbol of wisdom because of its cunning or guile. As a talisman against evil and sickness we find the serpent, the companion of the physician, twined around the staff of Aesculapias.
Staff	Symbol of divine power and justice used from the Pharaohs to present field marshals.
Stag	Through the act of shedding its antlers it symbolizes renewal (spiritual) or rejuvenation. In alchemy it was a symbol of Mercurius, a parallel to the Holy Ghost. In the legend of the Holy Grail Christ appears as a stag.
Sun	The life-giving force supplying light and energy from pagan to Christian times, it has symbolized the illumination and spiritual reality.

The Self	The inventor, organizer, and source of dream images from the psyche; the totality with which we are born and to which we must aspire. To the Naskapi Indians the soul of man is simply an inner companion, the "Great Man." By paying attention to their dreams they find they receive great riches in life. Dishonesty and deceit drive the "Great Man" away but love and generosity attract and give him life. The self has become commonly symbolized: by a mandala as a round or square structure; by a distinguished or royal couple, reconciling psychological opposites, male and female, and thus expressing wholeness; by an animal representing our instinctual nature (a myriad of helpful animals appears in myths and fairy tales); by the spirit of nature.
Tree	Psychic growth (individuation) occurs involuntarily and is represented by the growth of a tree.
Transcendence	The state of liberation from one type of existence to another, superior one. There are two types of transcendence (seemingly certain creatures use terrestrial life as an intermediary): *Chthonic transcendence*—bringing a special underworld message and symbolized by rodents or serpents. *Spiritual transcendence*— represented by the bird or wings. The caduceus or winged staff of Mercury is a composite symbol of both lower and spiritual transcendence. Other such symbols are the winged horse or winged dragon.
Water	The flow of water commonly symbolizes life and the crossing of a body of water or river is a frequent symbolic image for fundamental changes in attitude.

INDEX